J. PAUL GETTY

The Joys of Collecting

THE J. PAUL GETTY MUSEUM, LOS ANGELES

First published by Hawthorn Books, Inc., New York, 1965

© 2011 J. Paul Getty Trust

Published by the J. Paul Getty Museum, Los Angeles
Getty Publications
1200 Getty Center Drive, Suite 500
Los Angeles, California 90049–1682
www.gettypublications.org

Tevvy Ball , *Editor*
Jeffrey Cohen, *Designer*
Pamela Heath, *Production Coordinator*

Printed in China

NOTE TO THE READER: J. Paul Getty's memoir *The Joys of Collecting* was first published by Hawthorn Books, Inc., in an edition that included essays by Jean Charbonneaux, Julius S. Held, and Pierre Verlet. References to these essays in Getty's original text have been editorially elided for the present edition. Individual chapter titles have been provided as well.

Library of Congress Cataloging-in-Publication Data
Getty, J. Paul (Jean Paul), 1892–1976.
 The joys of collecting / J. Paul Getty.
 p. cm.
 Originally published: New York : Hawthorn Books, 1965.
 ISBN 978-1-60606-087-2 (pbk.)
1. Art—Collectors and collecting—United States—Anecdotes. 2. Art objects—Collectors and collecting—United States—Anecdotes. I. Title.
 N5201.G48 2011
 707.5—dc22

 2011016543

FRONT COVER: Writing and Toilet Table, French (Paris), ca. 1754. Jean-François Oeben, 1721–1763, master 1761. Oak veneered with kingwood, amaranth, tulipwood, and other stained and natural exotic woods; leather; silk; gilt-bronze mounts. 71.1 × 80 × 42.8 cm (28 × 31½ × 16⅞ in.). Los Angeles, J. Paul Getty Museum, 71.DA.103.
BACK COVER: J. Paul Getty, standing in front of the painting *Diana and Her Nymphs on the Hunt*, which Getty acquired in 1961.

Contents

Foreword

✦

J. PAUL GETTY (1892–1976) WAS SEVENTY-TWO years old when this book was first published nearly half a century ago. He had been collecting art seriously for almost thirty-five years, since the early 1930s, and as he declared in these pages, he thought his collecting days were over. He was mistaken: A decade later, in his autobiography, *As I See It*, he wrote of repeatedly—and always unsuccessfully—trying to kick the habit of buying art. For him, as for many others, collecting had become an addiction. In fact, in the months before his death at the age of eighty-three, he authorized the J. Paul Getty Museum's purchase of Greek and Roman marbles and ceramics, seventeenth-century European paintings, and eighteenth-century French and Italian furniture.

Getty made his fortune expanding the oil business established by his father, but as a young man he aspired to be a diplomat or a writer. Throughout his life he traveled widely, and he penned several books and a number of magazine articles. Much of his literary output, which included an occasional column for *Playboy*, addressed his business

dealings, philosophy, and wealth management, but he also researched and wrote seriously about the history of art, particularly French decorative arts, one of the three principal areas in which he collected, along with Old Master paintings and Greek and Roman antiquities.

Getty, who earned his first million dollars by the age of twenty-three and was named the richest man in the United States by *Fortune* magazine in 1957, was both visionary and conventional. In 1949 he surprised many people by paying more than $10 million for the mineral rights to a barren stretch of desert between Saudi Arabia and Kuwait. Four years later, this bet paid off when oil was discovered, and his wealth soared. (He once joked that his formula for success was to "rise early, work hard, strike oil.") Similarly nonconformist was his decision in the late 1960s, at the height of the Modernist movement in architecture, to erect a new building in the form of an ancient Roman luxury villa for his namesake museum in Malibu. Initially derided as kitsch, the Getty Villa is now among the most popular destinations in Southern California. In other ways, however, Getty's behavior was unsurprising: he seems to have craved association with aristocrats and celebrities and to have believed that great art could have a civilizing effect on those who viewed or acquired it.

The tone in *The Joys of Collecting* is largely didactic. Getty recounts personal anecdotes, discusses his philosophy of collecting, dispenses advice, and recalls his major triumphs, encouraging the novice to brave the perils and pitfalls of collecting art and to pursue, regardless of available finances, the drama, romance, and adventure that he himself had experienced. Some of the stories he tells are typical of the genre: He writes implausibly of the "housewife who picks up a bargain marble bust at a rummage sale" that turns out to be "a rare piece worth thousands" and opens the book with the story of his own acquisition, for a mere forty pounds, of a painting that in 1938 was considered to be a copy of a Raphael but was later acknowledged as a priceless original. (Research since Getty's death has demonstrated that this "Raphael" is, after all, an early replica of the Italian master's lost *Madonna of Loreto*, one of thirty-five such copies known today.)

Getty repeatedly encourages would-be collectors to study on their own and to avail themselves of the knowledge of experts, so as not

to be fooled by fake or misattributed works of art. "Before you invest, investigate," was his mantra, in art as well as in business. And he practiced what he preached: He acknowledges his reliance on the numerous specialists who advised him, and in the original edition of this book his essay was followed by chapters evaluating the highlights of his collection written by two Louvre curators, Jean Charbonneaux and Pierre Verlet, and by Julius Held, a professor at Columbia University. But even with expert guidance, as Getty observes, collectors make mistakes. Not only is his cherished Raphael not a Raphael; the marble torso of Venus allegedly found off the Italian coast at Anzio, near Nero's villa, turns out to have been not an ancient possession of the emperor—even though it was purchased from a reputable dealer—but a nineteenth-century piece. Getty himself unwittingly purchased at least one stolen work of art, a mistake he repeatedly warned others not to commit. The bas-relief from the Wix de Szolnay collection, which had been found on the northern Aegean island of Thasos in 1913 and which Getty obtained in 1955 through the London dealer Spink & Sons, was after his death identified as having been illicitly removed from an excavation depot years earlier. It was returned to Greece in 2006.

Although bold in his business dealings and occasionally impulsive in his acquisition of art—as in the purchase of ten canvases by the Spanish Impressionist Joaquin Sarolla y Bastida—Getty was not foolish, and he advises would-be collectors of antiquities to take special care not to contravene the patrimony laws of what today are often referred to as "source countries." Here as well Getty practiced what he preached: Entries in his diary for 12 and 13 August 1939, when he first began collecting ancient statuary in Rome, for example, record his negotiations with the dealer Alfredo Barsanti over the purchase of an ancient marble bust, variously identified at the time as portraying Livia, the wife of the emperor Augustus; Julia, the emperor's daughter; or Agrippina, his granddaughter. The final agreement stipulated the provision of export permits as well as shipping to the United States.

Getty always sought value for money and, like most of us, was exceedingly pleased when he got what he thought was a bargain, whether for the Lansdowne Herakles (now dated slightly later than he believed, to the early second century A.D.), for Rembrandt's *Marten Looten*, or

for the spectacular Ardabil carpet from Persia, the acquisition of all of which he describes in the following pages with considerable pleasure. Later in life Getty gained a reputation for stinginess, illustrated most famously by the installation of a pay phone in his mansion at Sutton Place, outside of London. In *As I See It* he goes to great—indeed, perhaps too great—lengths to explain that the phone was in use for only eighteen months and that it had been installed to protect the shareholders of Getty Oil, the legal owners of the property, from soaring phone bills occasioned by the many visiting businessmen, artists, and workmen passing through the house during its refurbishment. Reading his autobiography, one may likewise suspect that Getty protests too much when he offers detailed calculations to demonstrate how much he paid to build and maintain his museum in Malibu, stating that he was willing to foot this bill because of his desire "to make fine art freely available for viewing by the greatest possible number of people." Whether or not one accepts his claim that, after taxes, each visitor to his museum actually cost him three dollars, he clearly believed in the civilizing influence of great works of art; before opening his own museum, he donated, "not entirely without pain," the *Ardabil* carpet and Rembrandt's *Marten Looten*, two of his most prized works, to the Los Angeles County Museum of Art, so that they could be appreciated by the larger public. No collector gives away his best pieces just to obtain a tax break.

Getty began buying art in the 1930s, at a time when great works could be acquired at depressed prices. Like many other collectors, he did not turn away from purchasing desirable items later in the decade, when the rise of Nazism was forcing Jews and others to sell. Because of his collecting interests, Getty bought through established dealers and auction houses rather than directly from distressed artists or collectors in the manner, for example, of Peggy Guggenheim, who returned to Paris in the summer of 1939 determined, as she famously said, to "buy a painting a day" from artists anxious to sell, and who continued purchasing art into the spring of 1940, when the German army was advancing on the city. Writing more than twenty-five years later, Getty seems to rationalize his prewar acquisitions, noting in the present volume that some of his purchases in the late 1930s "were

made under conditions that were distressing to the owners of the items, conditions over which neither they nor I had any control whatsoever. It has been my earnest hope in all such instances that I was of some benefit to those who had to sell because I was the highest bidder, paying the highest price anyone present at the sale was willing to pay." Research over the past two decades has established that several European and American collectors and museums enhanced their holdings at the expense of Hitler's victims, but Getty, both before and after the war, always made his purchases from reputable dealers. For example, Paolo Veronese's *Portrait of a Young Man* (which is no longer considered to be a self-portrait, as Getty had believed), though once owned by Hitler's lieutenant Hermann Göring, was purchased by Getty in 1964 after it had been returned to a dealer representing its prewar owner. Similarly, François Boucher's *Venus on the Waves and Aurora and Cephalus* as well as several splendid pieces of eighteenth-century furniture, which the Nazis had looted from the Rothschilds in 1940, were restituted to the family after the war and subsequently purchased by Getty.

In these pages and in his other books, Getty wrote repeatedly of the pleasure afforded by beautiful objects, and thus it seems rather strange that, unlike so many collectors, he was content to live far away from most of his possessions. To be sure, he took some of his prized items to England, where they were displayed in the Great Hall and other rooms of his home at Sutton Place, but the vast majority of his collection was sent from dealers and auction houses directly to his museum in Malibu, a site that he did not visit after 1951, although he always intended to return there. Getty possessed a remarkable memory, which had much to do with his success in business, and his collection was never far from his thoughts. In addition, whether living in hotels in Paris or London in the early 1950s or traveling to Italy and visiting the renowned art historian Bernard Berenson, he seems to have carried with him a photographic record of the pieces he possessed. He researched many of his works of art—the *Marten Looten* was by no means an isolated instance—noting that through them "the collector can, at will, transport himself back in time and walk and talk with the great Greek philosophers, the emperors of

ancient Rome, the people, great and small, of civilizations long dead, but which live again through the objects in his collection."

The world, of course, has changed greatly in the half century since Getty penned these words. Building a collection of Greek and Roman antiquities from scratch, to take just one example, is now not only difficult but also widely recognized as potentially damaging to the archaeological record, for today information that can be derived from the context associated with an object is considered as valuable as the aesthetic pleasure it may afford. On the other hand, it seems that newspapers—and television shows—still enthusiastically report on lucky collectors who rediscover, as if by chance, priceless paintings and other long-lost masterpieces.

J. Paul Getty prided himself on following his own tastes in amassing artworks of incomparable beauty, but as a collector he was not radically original. Classical antiquities and Old Master paintings, as well as more esoteric European decorative arts, had long been sought and displayed as status symbols by the well-to-do, and Getty was especially proud to possess items previously owned by illustrious individuals, such as the emperor Hadrian, members of European royal families, and other aristocrats. Unlike many collectors, however, Getty seems to have been genuinely committed to sharing his art with the general public, and to that end, rather than restrict how his art might be shown or his bequest spent, in his will he dedicated his fortune to "the diffusion of artistic and general knowledge." In this way he gave the trustees of his estate free rein to extend beyond the dictates of his personal taste the range of genres and periods of art that the Getty Museum collects, and to expand the role of the Getty Trust in support of conservation, scholarship, philanthropy, and education.

KENNETH LAPATIN
Department of Antiquities
The J. Paul Getty Museum

J. Paul Getty as a young man.

A Word
of Introduction

I T HAS LONG BEEN MY BELIEF that some important gener-
alizations may safely be made about art collectors and collecting.

First, I firmly believe that almost anyone can become a collector,
and that he or she can start collecting at almost any period of life. One
need not be an expert or have large amounts of time or money to start
an art collection.

Second, I hold that few human activities provide an individual
with a greater sense of personal gratification than the assembling of a
collection of art objects that appeal to him and that he feels have true
and lasting beauty.

Third, I maintain that the true worth of a collection cannot—
and should not—be measured solely in terms of its monetary value.
Artistic merit does not necessarily follow the values set in the market.
Although price tags can be—and are—attached to works of art, the
beauty an individual sees in an object and the pleasure and satisfaction
he derives from possessing it cannot be accurately or even properly
gauged exclusively in terms of dollars and cents.

Last, I am convinced that the true collector does not acquire objects of art for himself alone. His is no selfish drive or desire to have and hold a painting, a sculpture, or a fine example of antique furniture so that only he may see and enjoy it. Appreciating the beauty of the object, he is willing and even eager to have others share his pleasure. It is, of course, for this reason that so many collectors loan their finest pieces to museums or establish museums of their own where the items they have painstakingly collected may be viewed by the general public.

These generalizations go far toward explaining why I have approved the publication of this book, and written the text which immediately follows.

My aim in writing *The Joys of Collecting* is an ambitious one. It is my desire to convey to the reader the romance and zest—the excitement, suspense, thrills and triumphs—that make art collecting one of the most exhilarating and satisfying of all human endeavors.

In my opinion, an individual without any love of the arts cannot be considered completely civilized. At the same time, it is extremely difficult, and sometimes impossible, to interest people in works of art unless they can see them and know something about them. It was for this reason that I established the J. Paul Getty Museum in Los Angeles a decade or so ago. A separate wing was built onto my home there to serve as a museum for the public. I am gradually giving my works of art to this museum.

In a manner of speaking, this book is an extension of the museum. It will enable many people who might never visit Southern California and the museum to see the beauty of the art objects it has been my good fortune to acquire, to know something about them and to understand the great joys I have experienced as a collector.

To those, collectors or not, who live in or near—or who may visit—Southern California, I extend a warm and sincere invitation to see the treasures I collected through the years and which are now displayed at the J. Paul Getty Museum. It is located on the Pacific Coast Highway in Malibu. The museum is open to the public, and admission is free.

I would also like here to express my deep gratitude to those who during my collecting days so kindly helped me with their connoisseur-

ship and learning, particularly to Colin Agnew, Bernard Berenson, John Brealey, Gerald Brockhurst, Jean Charbonneaux, Ludwig Curtius, Edward Fowles, Cecil Gould, Julius Held, Sir Philip Hendy, Leon Lacroix, Philip Pouncey, Stephen Rees Jones, Mitchell Samuels, Alfred Scharf, W. Valentiner, Pierre Verlet, Francis Watson, Paul Wescher and Federico Zeri. I was their earnest and grateful student whenever I was fortunate enough to be with them, and this has added greatly to my appreciation of art and my joys of collecting.

It is my earnest hope that this book will bring pleasure and be of interest and some assistance to those who are interested in the categories of art with which it is concerned.

I also hope that the account of my experiences as a collector will prove of some help and, perhaps, encouragement to other collectors, and especially those who would like to collect but, for whatever reasons, hesitate to do so.

I think that much of the hesitancy of the would-be collector will vanish if he simply bears in mind that every collector was once a beginner.

To the art lovers who have taken—or who will take—the first step, I extend my heartiest congratulations, for they will greatly enrich their lives.

Getty in Germany, ca. 1927. The Rhine River is in the background.

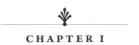

Beginnings

ON JULY 20, 1938, I WAS IN LONDON attending an auction at Sotheby's. At that time, Europe was already moving steadily closer to the brink of World War II. Civil war was raging in Spain. Italy had withdrawn from the League of Nations. Adolf Hitler had repudiated the Treaty of Versailles, annexed Austria and was making demands for the cession of Czechoslovakian territory to Nazi Germany.

Most Londoners felt there was little question that a general conflict was near and that, although the holocaust might perhaps be temporarily postponed, it could not be indefinitely averted.

I could sense the tension and gloom, the fear of impending disaster, wherever I went in the British capital.

Hence, it was hardly surprising that, while the sale at Sotheby's was fairly well attended, it had an almost desultory air about it. There was little of the customary subdued, but nonetheless electric, excitement to the bidding. Many of those attending seemed deeply preoccupied, lost in the contemplation of decisions being made and events taking place far away and beyond their control.

As an American—remember this was in mid-1938, more than three years before Pearl Harbor—I could sympathize with, but not quite share the feelings of the people who sat around me. Like the vast majority of my countrymen at that time, I was not fully alert to the dangers threatening the world. My attention was thus not distracted from less important and more immediate matters. I was at Sotheby's because I wanted to bid on several items that were listed in the sale catalog, which, incidentally, bore a cover announcement that would make any serious collector's mouth water:

Sotheby's Sale of Celebrated Paintings comprising the Collections of The Royal House of France removed from Schloss Frohsdorf, Lower Austria and now sold by order of H. R. H. Princess Beatrix de Bourbon-Massimo.

The paintings being offered were from the collection of the late Jaime III of Bourbon. Many of them had originally been in the Tuileries, but were removed to the Castle Frohsdorf, which became the home of the Bourbons after their exile following the Revolution of 1830. The auction had been ordered by Princess Beatrix, the niece and heiress of Jaime III.

The day before the sale, I examined the paintings that were to be offered, and I became interested in four that were to be sold in three lots. Lot No. 30 consisted of two flower pieces attributed to Van Huysum.

The other two Lots—49 and 136—were of particular interest to me. The former was one of three "after-Raphael" paintings listed. These were Lot No. 48: The *Madonna del Passegio*; No. 49: The *Madonna of Loreto*; and No. 50: *The Holy Family (La Perla)*. Lot No. 136 was a large, 144- by 64-inch Rigaud portrait of Louis XIV.

I decided I needed some expert advice before bidding on the *Madonna of Loreto* and the Louis XIV portrait. Gerald Brockhurst, the well-known English portraitist—who, I might add, painted my own portrait that same year—acted as my adviser in regard to the *Madonna*. He recommended that I purchase the panel, for he strongly suspected that it was not simply an "after-Raphael" painting; he believed the fore-shortening of the Virgin's right arm betrayed the master's own touch.

Leon Lacroix, an expert on French eighteenth-century art, gave me his opinion on Lot No. 136, the Louis XIV portrait. He thought it a good example of Rigaud's work.

And so I decided to buy, if I could, both these paintings. I really didn't have any set price limit in mind. I think that nearly all the art dealers of London and Paris, as well as numerous museum experts and private collectors, were present at the sale, and I expected stiff competition in the bidding.

As the sale progressed, it became apparent that those present were not inclined to pay high prices. When Lot No. 30—the flower pieces attributed to Van Huysum—was auctioned I bought it with a top bid of 55 pounds, in those days approximately $275.

A few minutes later, Lot No. 49 came up for sale. It was a panel that seemed unprepossessing at first glance. In fact, it was in a somewhat poor condition. It dealt with a classic subject, a portrait of the Holy Family. No special claims were made for it. The painting, it seemed, was a copy of Raphael's famed, long-lost *Madonna of Loreto*. It might have been executed by one of Raphael's students or contemporaries. Apparently no one else attending the sale had anything approaching my interest in the panel, and evidently none had seen what Gerald Brockhurst had noticed in the painting.

I waited for the opening bid, which proved to be 10 pounds, or about $50. By then an experienced and cautious auction buyer, I increased the bid only slightly, which someone promptly topped by another few pounds. And so it went, back and forth, until I bid 40 pounds—roughly $200—and there was no further competition. Lot No. 49 was mine. My 40-pound bid was more than anyone else was willing to pay.

My luck held when Lot No. 136 was offered. I purchased Rigaud's portrait of Louis XIV with a winning bid of 145 pounds (about $725). Soon afterward, I had the items I had purchased at various auctions shipped to New York.

My liking for the "after-Raphael" panel continued to grow after it was in my possession. I was constantly drawn to it, intrigued by it. And, I had confidence in it. To employ a colloquialism, the painting "had something"—something which set it apart, a quality which exerted an

Getty gazes at one of his favorite paintings, The Holy Family, *which he bought at auction in 1938 for forty pounds. It is now known to be a mid-sixteenth-century copy, after Raphael's* Madonna of Loreto.

ever increasing attraction and fascination.

Years—twenty-five to be exact—passed. Although my collection expanded greatly and I had been lucky enough to acquire several very important additions to it in the interim, the $200 *Madonna* remained one of my favorites. In 1963, I had the painting shipped to Sutton Place in England.

There were some abrasions of the original paint, and there seemed to be thick daubs of repaint and discolored varnish covering the panel.

8

A few days after the painting arrived at Sutton Place, Colin Agnew, the prominent London art dealer and expert in Italian Renaissance paintings, visited Sutton Place and I asked him to look at the *Madonna*.

He was not impressed by the work. Quite to the contrary. He asked a friend of mine why I had purchased it. When told that I thought it was a Raphael, Colin blinked.

"Who in the world ever sold *that* thing to Paul as a Raphael!" he exclaimed.

Colin did, however, suggest that the painting badly needed cleaning. I followed his advice and sent the panel to him to be cleaned, and when the work was finished the quality of the picture became more evident. At this point, Colin became convinced that the *Madonna of Loreto* was by the master's own hand.

Subsequently, on the advice of a leading art historian, I had the picture given a thorough "stripping." This involved removal of all or almost all of the repaint to reveal the original work. As a result, the great quality of the painting became evident. One could now definitely see the early-sixteenth-century work of the master, Raphael, free of the disfiguring repaint of later generations.

Colin Agnew consulted with Dr. Alfred Scharf, an authority on fifteenth- and sixteenth-century Italian paintings. After meticulous study of the panel, Dr. Scharf accepted it as an autograph work of Raphael.

The discovery caused a very considerable stir throughout the art world. Other experts who have since examined the panel and the infrared photographs and X-rays that were taken of it concurred with Dr. Scharf's verdict.

As these words are being written, the *Madonna of Loreto* is on display in the Raphael Room of the National Gallery in London, to which great museum I loaned the painting in February 1965. It hangs next to another masterpiece of the immortal Raphael—his *Aldobrandini Madonna*.

Insofar as the monetary value of the *Madonna of Loreto* is concerned, authenticated as a genuine Raphael, it is virtually priceless. It is insured today for 10,000 times the price I originally paid for it!

I cite this for the same reason that I began my narrative with the story of this painting—to highlight the excitement and drama inherent

in collecting and to demonstrate as forcibly as possible that there is often high adventure in collecting art. No matter how modestly he begins, there are no fixed limits or ceilings to halt or hinder the collector.

My own career as an art collector is, in many ways, a fairly illustrative case.

My interest in fine art was slow in awakening; my interest in actually collecting art was even slower.

I made my first visit to Europe with my mother and father in 1909. As part of our tour, we visited the Louvre in Paris and the National Gallery in London. Neither of these fabulous museums made much of an impression on me; perhaps I was still too young to appreciate what I saw.

Three years later, I returned to Europe—or, rather, to England, where I enrolled as a student at Oxford University. University regulations required me to be in residence for three six-week terms during the year. The remainder of the time, I was free to do very much as I pleased. I chose to travel.

I was a good, almost a model Cook's tourist. I faithfully made the rounds of the museums and galleries. Even so, my love of fine art still seemed to be dormant. I can recall being impressed by only one painting, that of *Venus* by Titian in the Uffizi in Florence.

Incidentally, in May and June of 1912, I had made a trip to China and Japan. I suppose that if one stretched the point almost to breaking, it could be said I started my collection during this visit to the Orient. I purchased my first art objects, two Chinese bronzes and some pieces of carved ivory. I seriously doubt that I paid much more than the equivalent of fifty dollars for the entire lot.

It was a timid and faltering start. The seeds of the urge to collect took an unseemly long time to sprout. Eighteen years were to pass before I resumed collecting again.

True, there were many totally unrelated forces and factors that served to inhibit my activities in these directions. Returning to the United States after obtaining a diploma in economics and political science at Oxford, I began wildcatting for oil in Oklahoma. Not until early 1916 did I bring in my first producing oil well, and from then on, except for a lull of less than a year, I devoted my time and energies to

building and expanding my business enterprises.

Nevertheless, I found my interest in art growing and developing. I read voraciously on the subject and visited museums and galleries during my infrequent periods of leisure or holiday, not because these were the "things to do," but because I truly enjoyed doing them. Paradoxically, the more I learned, the more my knowledge served to dampen any inclination I may have had for collecting.

In the mid- and late 1920s, very few works of art of good quality were to be found on the market. The best examples of almost all forms of fine art were in museums, huge private collections, or held by very strong hands.

The United States was enjoying a period of tremendous prosperity, and there were great numbers of extremely wealthy men in Britain and Europe. They bid against each other for whatever came on the market. Prices on those items that were available spiraled completely out of proportion to any reasonable scale of values.

Although I had achieved a degree of business success, I was certainly in no position to compete with collectors of the caliber of the Hearsts, Mellons or Rothschilds. Besides, since my business enterprises were still expanding, I reinvested most of my profits in them. I had only relatively small sums of ready cash at my disposal.

Withal, in the late 1920s, it appeared to me that the days of collecting were just about over. The men who had made their millions and tens of millions before I'd started in business—or even before I was born—swept up just about everything worthwhile that had found its way to the market over the past few decades. The old aristocratic British and European families who still possessed treasure troves of fine art were, for the most part, very well situated financially in those days. And, even if they were not and decided to sell an item or two, they had been conditioned to the idea of entertaining only the most staggering offers for their possessions.

The entire situation changed with awful suddenness. The great panic—the "Crash"—of 1929 shook the art world no less than it did the financial world. The 1930s brought no convincing recovery.

The Depression settled over the United States and spread to Britain and Europe. Now, many of the strong hands that formerly held some

of the finest examples of art on the face of the earth were forced to relax their grip. Many choice items became available for purchase, and art prices, like all other prices of the time, dropped to levels which would have been inconceivable a few years or even months earlier.

Here was an opportunity for the would-be collector with comparatively limited means, which could not possibly have been foreseen before 1929. As I became aware of this, my long-dormant urge to collect things of beauty and examples of fine art finally awoke.

In 1930 I bought a painting by Van Goyen for about $1,100. By 1932 I was actively acquiring paintings, sculptures and other works of art of museum quality.

I continued collecting until 1964, when I more or less stopped. I felt that I had acquired enough, that I had assembled a collection of which I could be proud—and that I should leave the field to others.

My collecting over the years has been a labor of love and, I believe, it might make a story worth telling.

CHAPTER II

Building
a Collection

AT SOME POINT OR ANOTHER, preferably as early as possible, the collector must make up his mind what it is precisely he wishes to collect. The decision can lie anywhere between two widely separated extremes.

He may, for example, limit his collection solely to bronzes of a certain period or even of a specific century and national origin. At the other extreme, he may conceivably emulate the late William Randolph Hearst who literally collected everything from prehistoric figurines and old masters to castles and their entire contents.

The choice a collector makes is necessarily guided and governed by many and various factors and influences. The most important consideration is, of course, the simplest one of all: in what direction or directions do his interests in and liking for fine art lie?

What is the ultimate in artistic beauty to one person, may well be a bore or an abomination to another. This should be obvious to anyone who has ever watched any sizeable group of people making its way through a large museum.

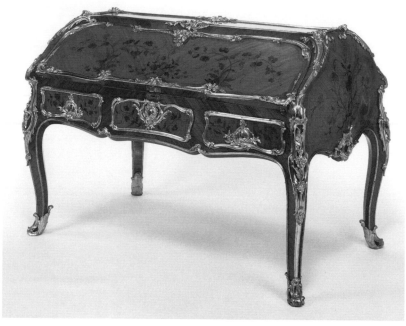

Double Desk. Paris, ca. 1750. By Bernard II van Risenburgh (French, after 1696–ca. 1766). Oak veneered with tulipwood, kingwood, and bloodwood; drawers of mahogany; gilt-bronze mounts. H: 107.8 × W: 158.7 × D: 84.7 cm (3 ft. 6½ in. × 5 ft. 2½ in. × 2 ft. 9⅜ in.). Los Angeles, J. Paul Getty Museum, 70.DA.87.

There are those in the group who will glance at a Goya and give a disinterested yawn, but who will stand transfixed, gazing with awe at a Gauguin. To some, Bernini is an anathema, while Rodin is sublime. There are individuals who respond enthusiastically to Venetian Settecento furniture but remain completely unmoved by the finest examples of the eighteenth-century French cabinetmakers' art.

And so it goes.

The variations and differences between individual tastes, likes and dislikes are infinite in regard to almost everything in life. When it comes to fine art, individual tastes and preferences become even more pronounced—this is especially so with collectors.

Possibly, it is as Aline B. Saarinen has said, that for the true col-

lector, "the collecting of art [is] a primary means of expression." Without doubt, the collector reflects much of his innermost self, his convictions, attitudes and outlooks in what he collects.

My own philosophy regarding my collection can be summed up by a paragraph Ethel Le Vane wrote in the book, *Collector's Choice*, a decade ago:

> To me, my works of art are all vividly alive. They are the embodiment of whoever created them—a mirror of their creator's hopes, dreams and frustrations. They have led eventful lives—pampered by the aristocracy and pillaged by revolution, courted with ardor and cold-bloodedly abandoned. They have been honored by drawing rooms and humbled by attics. So many worlds in their life-span, yet all were transitory. Their worlds have long since disintegrated, yet they live on—and, for the most part, they are as beautiful as ever.

Banal as it may sound in this glib and brittle age, the beauty that one finds in fine art is one of the pitifully few real and lasting products of all human endeavor. That beauty endures even though nations and civilizations crumble; the work of art can be passed on from generation to generation and century to century, providing a historical continuity of true value.

When I began to collect actively, I determined to keep my collection comparatively small and to purchase only items of the highest artistic quality and merit. I felt that I would much rather own a few choice pieces than amass an agglomeration of second-rate items. I also resolved to concentrate on certain schools, largely limiting myself to those that I liked best and interested me most. Therefore, the majority of my collection consists of the following categories:

> Greek and Roman marbles and bronzes; Renaissance paintings; sixteenth-century Persian carpets; Savonnerie carpets and eighteenth-century French furniture and tapestries.

I have, of course, made several exceptions and digressions. It might, I think, be interesting to the reader, and amusing in at least one instance

if I touched upon the circumstances surrounding some of these digressions before continuing with the story of my collection proper.

As an example, I recall one purely accidental and unintentional purchase I made at Christie's a few years ago. The day was warm and the auction rooms were terribly crowded. For some unknown reason, no one had thought to open any windows. The atmosphere inside gradually became hotter and stickier, eventually to such a degree that I was completely distracted from the sale then in progress. A friend sat next to me and also suffered from the heat and lack of fresh air.

"You'd think the staff would do something about the ventilation in here," he commented to me *sotto voce*.

I nodded agreement and unconsciously reached up to loosen my shirt-collar. A moment later, I noticed the auctioneer pointing directly at me.

"Yours, sir—for one hundred guineas!" he announced loudly.

I blinked at him in astonishment. For several seconds I was completely baffled and then I realized what had happened. While I had been fretting about the ventilation and paying no attention to the sale, a painting was being auctioned. The bidding had reached the point at which the auctioneer was asking, "Will anyone offer a hundred guineas?"

Now, art auctions have their etiquette. Buyers seldom call out their bids. They "telegraph" them through surreptitious movements of their hands or heads, by a flick of the catalog they hold or some other, similar means. Veteran auctioneers are constantly alert for such signals.

Thus, when for the third time, Christie's auctioneer had asked if anyone would offer one hundred guineas for the item then being offered and I made as if to loosen the collar of my shirt, he took it as a signal that I was willing to pay the price.

My consternation quickly became apparent to all those seated near me and occasioned much sympathetic laughter. I laughed, too. There was nothing to do but accept the situation with good grace, and I consequently became the owner of what was listed in the sale catalog as "No. 18-A: A watercolor of old London about 1845."

The circumstances surrounding another of my digressions as a collector were far different. In November 1933 I attended the Thomas Fortune Ryan sale at the Anderson Galleries in New York City. There

I purchased a total of twelve pieces. Ten were paintings by the Spanish Impressionist Joaquin Sorolla y Bastida, who died in 1923. Obviously, his work did not fit any of the five major categories into which I intended to channel my collecting efforts.

However, I was struck by the remarkable quality of Sorolla's paintings, being especially fascinated by his unique treatment of sunlight. I bid on the ten canvasses and the two other items I bought during the sale for an overall price of considerably less than $ 10,000. I have never had any cause to regret my decision.

Looking at the acquisition from an investment standpoint, it was a highly fortuitous one. By 1938 the monetary value of the ten Sorollas had risen to $40,000.

Although the purchase of these Impressionist works was a major digression from my usual fivefold collecting path, my opinion regarding their beauty, appeal and artistic merit remains the same as it was when I first saw the canvases.

I have made other exceptions to my general five-category rule. Among them are some excellent English portraits by Gainsborough and Romney. One Gainsborough has been described as "one of the really great English portraits" by no less an authority than Dr. Julius S. Held, professor of art history at Barnard College, Columbia University. There is, I might add, a tinge of irony in the fact that I own it. The portrait is of James A. Christie, founder of Christie, Manson and Woods, the world-famous London auction-gallery generally known as Christie's.

The portrait was painted in 1778, when James A. Christie was 48. It was immediately recognized as one of Gainsborough's finer works and was exhibited at the Royal Academy in London in 1778, 1817 and 1859, and subsequently at several other major exhibitions.

How and why the Christie family, steeped for generations in knowledge and appreciation of fine art, permitted this exceptional work and priceless heirloom to slip out of its hands is an unfathomable mystery. However, in 1927 it was sold—at Christie's—for 7,560 pounds sterling. The purchaser was Thomas Agnew & Sons, another art dealer. In 1938, I bought it from Colnaghi's Gallery for 7,500 pounds. It was, incidentally, one of a group of paintings that I loaned to the New York

Thomas Gainsborough (English, 1727–1788), Portrait of James Christie, *1778. Oil on canvas, 126 × 101.9 cm (49 ⅝ × 40 ⅛ in.). Los Angeles, J. Paul Getty Museum, 70.PA.16.*

18

World's Fair for exhibition in 1939. Another was Rembrandt's *Portrait of Marten Looten*, which has a fascinating history about which I shall have more to say later.

In recent years, I have, on occasion, wandered even farther afield in my collecting. Among my acquisitions have been two fine works by Edgar Degas, each of which brilliantly demonstrates an entirely different facet of his genius. The first is *Sea-Side Landscape*—indeed a rarity, for Degas devoted the majority of his work to scenes from the theater and ballet. It was only during a comparatively brief period of his long career that he produced a handful of canvasses and pastels inspired by the sea. My other Degas, *Three Dancers in Pink*, is an excellent representative example of his traditional work. As the title implies, it depicts a trio of female dancers, and the composition, color and treatment give the canvas a throbbing, vital quality.

Another purchase was a painting by Claude Monet, *The Cliffs of Pourville in the Morning*. Painted near Dieppe in 1897, this is a work to which Monet imparted a deeply moving lyrical quality by bathing the scene in a tremulous blue light.

Landscape Near Rouen by Paul Gauguin is also a comparatively recent "offbeat" addition to my collection. It is a lovely work and unusual for at least two reasons: As an early Gauguin—it was painted in 1884, six years before he set up his studio in Tahiti—it has a very pronounced Impressionistic quality. Second, there are very few Gauguin landscapes extant that do not date from his Brittany period or from the time he stayed in Provence. An added feature of interest is the inscription that appears on the painting: "*A mon ami* William Lund."

In 1956 I purchased Auguste Renoir's jewel-like *The Village of Essoyes*. This is a small canvas, scarcely 10 by 12 inches in size, but it is an exquisite painting of the village in the Aube for which the artist bore such great love and to which he had such a strong attachment. It was the birthplace of his wife and his famed model Gabrielle. Renoir bought a house there and spent many of his summers in it. It was in Essoyes during the summer months that he received an endless flow of visitors, among them a great many of the younger painters of the period who were influenced by him and later made their own reputations in the world of art.

Finally, I would like to mention just one more of my latter-day digressions, Pierre Bonnard's *Woman in the Nude*. "Strikingly composed," is Dr. Julius Held's comment on this large (approximately 54 by 31 inches) painting by Bonnard who, with Edouard Vuillard, had such a profound influence on the direction painting took in the post-Impressionist period.

Obviously, I have deviated far from my main theme—the body of my collection—even before making a proper beginning. But first, I chose to dispose of the exceptions to my self-imposed rules governing the categories of art I had decided to collect, for a reason. The few representative digressions I have described serve to illustrate that even the collector who is grimly determined to specialize or limit himself is highly likely to be led, or to lead himself, down many detours and byways.

Although he may prefer one or a few types or schools of art to all others, his acquaintance with and understanding of one or certain specific forms of beauty cannot help but extend and expand his aesthetic horizons. He cannot avoid, sooner or later, recognizing and appreciating other forms, other schools, other categories of fine art. As his specialized collection grows, so his tolerance, his understanding and appreciation will grow. And so will his depth and dimension as a perceptive, sensitive and well-rounded individual.

Greek and Roman Antiquities

I HAVE SAID THAT THE COLLECTOR frequently experiences thrills and sometimes savors triumphs. My "find" of Raphael's *Madonna of Loreto*, already mentioned—is an exemplary illustration of this. Equally great is the sense of triumph a collector experiences when he succeeds in acquiring a unique work of exceptional artistic and historical value that he and the entire art world have long believed to be absolutely unobtainable at any price.

It has been my immense good fortune to have had such experiences on several occasions during my career as a collector. Some of the more outstanding of these have occurred in my collecting of Greek and Roman antiquities.

One of these exceptional triumphs was my totally unexpected—and theretofore completely undreamed of—success in obtaining the celebrated Lansdowne *Hercules* (or *Herakles*) for my collection.

There is evidence to suggest that this large (76¼ inches high) Pentelic marble statue was a great favorite of the Roman Emperor Hadrian, who was the most sophisticated of all ancient Roman emper-

ors. It is a first-century B.C.–first-century A.D. Roman replica of a work by Scopas.

The statue was found in 1790 in the ruins of Hadrian's villa outside Rome. For a brief time, it was the property of an aristocratic Roman family, but in 1792 it was purchased by an English nobleman, the Marquis of Lansdowne, who paid 600 pounds sterling for it. He took the statue to England, where he was assembling a truly important collection of statuary in his luxurious Berkeley Square house.

The fame of the Lansdowne *Hercules* grew through the decades. It was generally conceded to be the finest piece in the entire Lansdowne collection and, in fact, one of the finest examples of classical statuary anywhere outside Greece or Italy.

Adolf Michaelis, the German-born archaeologist and leading authority on ancient marbles in Great Britain, pronounced the Lansdowne *Hercules* to be "perhaps the most important classical statue in English collections."

The *Hercules* has figured prominently and received the highest praise in the works of other leading experts, including Gisela Richter and Adolf Furtwängler.

The statue remained in the possession of the Marquis of Lansdowne's descendants. Dealers and collectors alike assumed that it was untouchable, that the family could never be induced to part with it—or, at the very least, only at an astronomical price. They knew the Lansdowne family had sold another piece in the collection, *Wounded Amazon*, in 1930 when art prices were already depressed. This statue was considered inferior to the *Hercules*, but nonetheless, it was purchased for a staggering 28,000 pounds sterling (then nearly $140,000) by John D. Rockefeller, Jr. With such a precedent established, what offer, if any, would the Lansdowne family entertain for the fabulous *Hercules*? One dared not even think.

Then, one afternoon, I was browsing in Christie's. I chatted with the manager and invited him to have lunch with me the following day

The Landsdowne Herakles, *Roman (Tivoli), now dated to ca. A.D. 125. Marble, H: 193.5 cm (76⅛ in). Malibu, J. Paul Getty Museum, 70.AA.109.*

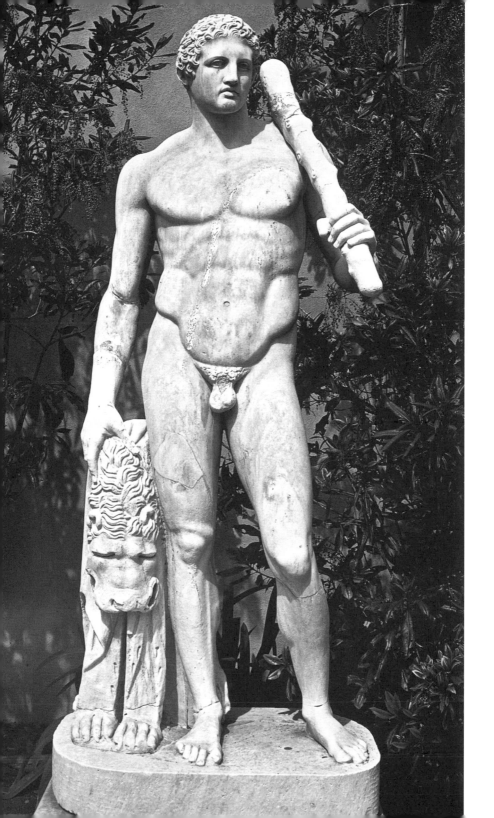

at the Ritz Hotel, where I was staying. During the course of the luncheon, I mentioned that I was in the market for ancient marbles. My companion's next remark practically stunned me.

"I would prefer not to be quoted," he said, "but I've heard rumors there might be a possibility of something being available from the Lansdowne Collection. As you doubtless know, the family deals mainly through Spink & Son."

My collector's instincts snapped to attention, and a sudden though only very faint hope arose. Could there possibly be a chance of obtaining the Lansdowne *Hercules*? I braced myself psychologically for what I was certain would be an eventual refusal and soon began the necessary diplomatic overtures to the Lansdowne family through Spink's. The negotiations were protracted, and there were several disheartening days when I was sure that I had failed.

At last, to my incredulous joy, the family made its decision—one, which for me, was fantastically favorable. Yes, I could have the Lansdowne *Hercules*, for the astounding price of 6,000 pounds, plus a 10 percent commission to Spink's. What was more, the family was willing to part with another piece, a Pentelic marble group of *Leda and the Swan* for only 500 pounds, plus Spink's commission.

Thus, the Lansdowne *Hercules* soon began its journey westward, to the United States. How Michaelis would rank the *Hercules* among the collections of classical statuary in the United States is something I do not know. It is enough for me to know that this magnificent marble sculpture, which once delighted the Emperor Hadrian and for a century and a half was a pride of Britain, is now completely "Americanized"—on view for all to see at the Getty Museum.

Another unforgettable triumph of my collecting career was my luck in obtaining three other "impossible" pieces, three of the world-famous Greek "Elgin Marbles" for my collection.

The "Elgin Marbles" as such have a fascinating history. It begins with Lord Thomas Bruce, 7th Earl of Elgin and 11th Earl of Kincardine, who during his lifetime (1766–1841) earned great distinction as a British diplomat and as an archaeologist. While serving as British Ambassador to the *Porte* (Greece was then part of the Ottoman Empire) Lord Elgin assembled a fabulous collection of pre-Christian

Greek marbles, including the famed and breathtaking Parthenon frieze, and arranged for shipment of the collection to England.

The bulk of this collection, by far the finest of its kind anywhere in the world outside Greece, went into the British Museum, where it has since been viewed and marveled at by millions of people. Lord Duveen, the renowned art connoisseur and dealer, saw the collection many decades after Lord Elgin's death. He was so impressed that he donated a gallery to the British Museum—now known as "The Elgin Marbles Room"—so that the treasures could be displayed to best advantage.

Although the major portion of the marbles that Lord Elgin transported to England from Greece went to the British Museum, he retained a few pieces for his own private collection. For generations, they remained the property of his descendants, and it was virtually an article of faith among dealers and collectors that they would never, under any circumstances, become available.

Then one day while on a trip to Italy, I received a letter from Mrs. Ethel Le Vane. I read it and could scarcely believe what I read. The letter informed me in the strictest confidence that the 10th Earl of Elgin might—just *might*—be willing to sell three of the Elgin Marbles that remained in the family's possession. Would I be interested?

Would I! I wasted no time, but dispatched an affirmatory cable immediately. The three pieces in question were at Lord Elgin's ancestral mansion, Broom Hall, in Scotland. They consisted of the following:

1. *Myttion*, a fourth-century B.C. sepulchral stele representing the figure of a young girl with short, curly hair.
2. An Archaic *Kore*, or female figure, 28 inches high, made of Parian marble, of Attic origin and dating from the early fifth century B.C.
3. A sepulchral stele of Theogenis, Nikodemos and Nikomache dating from the early part of the fourth century B.C.

Needless to say, lengthy and delicate negotiations had to be made, export permits obtained and many other details attended to before the three precious pieces were mine. Withal, I was successful—and, as a collector, it was one of my great triumphs.

I derive much pride and satisfaction from my success in obtaining these three examples of the fabled Elgin Marbles and thus making it possible for my own countrymen to see and admire them in the J. Paul Getty Museum in Los Angeles.

In 1953 I paid a visit to that all-but-legendary figure of the art world, the late Bernard Berenson, at his villa I Tatti in Settignano, not far from Florence. Although I was aware that "B.B." did not particularly relish looking at photographs of works of art—a perfectionist, he wanted to see the actual object—I had brought along some photos of my Elgin Marbles and showed them to him. I was hardly prepared for his reaction when he saw the photograph of *Myttion*.

"Come over here and see something really great!" he exclaimed delightedly to one of his associates. "Now *this* is a piece I would love to have!"

For any collector, Bernard Berenson's enthusiastic response would have been a rare and special bounty, and I was no exception.

Jean Charbonneaux, member of the Institute of France and Keeper of Antiquities at the Louvre, states that the Elgin *Kore* is one of the three rarest pieces in my collection of Greek and Roman antiquities. Another, he feels, is the Thasian bas-relief dating from the early fifth century B.C. that was found on Thasos in 1913 and which I obtained from the Wix de Szolnay collection. The third is the celebrated *Cottenham Relief*, which has a strange story of its own.

This Pentelic marble bas-relief—actually only an 11- by 12-inch top left-hand fragment of the original—dates from *circa* 500 B.C. It depicts a young man leading a horse by its bridle. The workmanship is exquisite.

"In this handsome fragment, all the grace of archaic Greek art is to be seen," says Charbonneaux.

The *Cottenham Relief* came to light in our present century, in 1911 to be exact, but it was not found in Greece. Paradoxically, it was discovered 18 inches beneath the surface of the ground, turned up by a laborer's pick, in England! The fragment was found in Cottenham, near Cambridge.

How did this sublime example of archaic Greek art reach England and become "lost" and "found" there? The precise details will never be

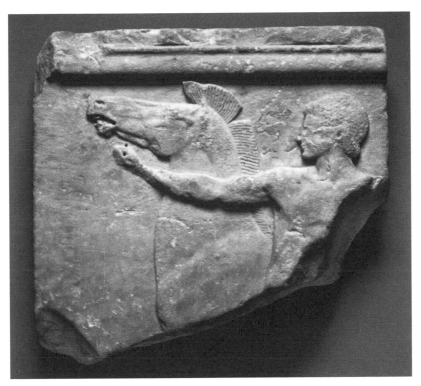

Votive Relief (The Cottenham Relief), Greek, ca. 500 B.C. Blue-gray marble. H: 27.6 × W: 30.5 cm (10⅞ × 12 in.). Malibu, J. Paul Getty Museum, 78.AA.59.

known, but an entirely satisfactory skeleton of the explanation can be readily reconstructed.

Roger Gale (1672–1744), a noted antiquarian of his time, lived in the manor house at Cottenham in 1728. The fragment, or perhaps the entire original, almost certainly belonged to him. Somehow, possibly during the moving of his effects into or out of the house, the fragment was dropped on the ground or broke off the original. It is even within the realm of possibility that the fragment was left behind and thrown away by the subsequent occupants. In any event, it was trodden into the earth, where it remained until a laborer accidentally uncovered it nearly 200 years later.

It should hardly be necessary to say that by no means was every addition to my collection of Greek and Roman antiquities a triumph, and that by no means does every piece have such an odd recent history as the *Cottenham Relief*. Many of the items in the collection were acquired in the most prosaic way.

For example, my *Torso of Venus*—an almost life-size torso reputed to have been found in the sea at Anzio, not far from Nero's villa—was simply purchased from the Barsanti Galleries in Rome in 1939.

The Legend of Orpheus, a Gallo-Roman mosaic dating from the second or third century A.D., came into my possession via the William Randolph Hearst auction held at the Hammer Gallery in New York in 1941. This large mosaic (it measures 191¾ inches by 139 inches) is intriguing for its intricate motifs and geometric designs. It was found in France, but is of Roman workmanship.

The fashion of constructing mosaic floors consisting of tiny colored stones and occasionally pieces of glass originated in the Orient. In Hellenistic times, it was particularly popular in Alexandria. Mosaic floors were introduced in Rome, other parts of Italy and in the Roman provinces during the Republican and later periods. High-ranking administrators and officials posted to the provinces frequently brought skilled artisans from Rome to construct mosaic floors for their villas.

When I purchased the mosaic at the Hearst sale, it had been cut into many sections and packed in crates. I decided to have it installed on top of the existing floor in what is now known as the "Roman Room" of the J. Paul Getty Museum.

I sought the advice of a firm that specialized in antique marbles. I was told that relaying an ancient mosaic floor was an intricate task of monumental proportions and that there were only a handful of skilled artisans in the United States capable of handling the task. The firm itself knew of only two such men—and several weeks were needed before one of them could be contacted. I had to bring him to Malibu from the East Coast, naturally paying all his traveling expenses.

The man's basic wage was five dollars an hour—and this was quite a number of years ago. He needed two months of painstaking labor, working eight hours a day, five days a week, to lay the mosaic floor. But it was well worth the cost, for he did a magnificent job. The mosaic floor

depicting the *Legend of Orpheus*, which once graced some powerful Roman official's villa in Gaul, now provides a perfect decorative touch to the museum's Roman Room in which are displayed numerous Roman and some Hellenic antiquities I have collected.

So far, I have mentioned only some examples of marbles and, of course, the mosaic that are part of my Greek and Roman antiquities collection. I have also been fortunate to acquire some fine ancient bronzes. Among them is the statuette, *Phrixos*, a masterpiece of Polycletian style. It was originally in the Julius Böhler collection in Munich. Such is the rare quality of this bronze, that I gladly loaned it for exhibition to the Louvre for a few years.

Jean Charbonneaux, Keeper of Antiquities at the Louvre Museum, inclines to the belief that this *Phrixos* is a Greek original dating from the early fourth century B.C. He describes it as "very beautiful" and says "the statuette occupies an essential place in the history of this important period (fourth century B.C.), during which a transition was effected, from an aesthetic based on the ideal to one which turned towards the actual."

Unfortunately, space does not permit me to go into detail about more of the ancient Greek and Roman objects in my collection and the manner in which they were obtained. At this point, however, it might be well for me to make a few observations based on my own experiences regarding the collecting of Greek and Roman antiquities.

To start with, the reader has doubtless noted that most of the items I've described were obtained from other private collections or, with a few exceptions, from dealers *outside* Greece or Italy. There are good reasons for this.

For many years, both Italy and Greece have enforced strict embargoes on the exportation of antiquities which were not already in private or dealers' hands at the time the laws were passed. The purpose of these laws is, of course, to insure that no additional art treasures are lost to the countries.

It is true that museums, universities and similar institutions will organize archaeological expeditions and projects and will frequently discover new troves of art and artifacts. However, even such activities are subject to stringent controls. The host country, Greece or Italy,

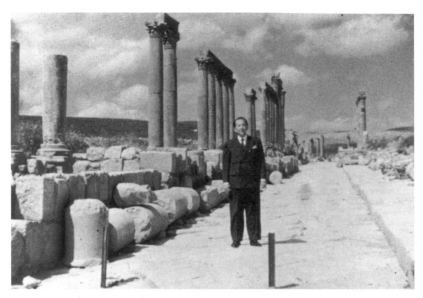

Getty at Jerash (ancient Gerasa), in modern Jordan.

may issue permits for archaeological projects and excavations, but seldom if ever to private groups or individuals. And the permits are granted solely with the proviso that the bulk—and usually the best—of any and all art or artifacts uncovered belong to the host country. The foreign archaeologists may take only a certain share of what they find back to their own countries, and then usually only if they are to be placed in university collections or public museums.

Ancient Greek and Roman art objects that were not already in private hands years ago are the property of the State or public museums. The days when a Lord Elgin could ship large quantities of ancient Greek marbles out of Greece are long past.

There are exceptions, of course. An Italian farmer excavating the foundations of a new barn might accidentally unearth a marble bust or a bronze statue. If he is sophisticated and unscrupulous enough, he will not report his find to the authorities, but will slip the object to some dealer no more scrupulous than himself. The dealer will, in turn, either offer it "under the counter" to some especially avid or

particularly gullible collector, or will smuggle the object out of the country and sell it abroad.

To buy any object from such dubious sources is obviously risky. In the first place, the buyer is contravening, or at least conspiring to contravene, the law, and is liable to penalties ranging from heavy fines to actual imprisonment. Then, the "rare object" he is buying may not be at all what it is represented to be. It could be a forgery, or even an object that has been stolen from a museum or private collection.

To all intents and purposes, the modern-day collector of ancient Greek and Roman art must confine himself to buying from one or another of two sources—well-established and highly reputable dealers or other collectors.

Even then, the wise collector will have the object he wishes to buy vetted by an outside expert, or even several independent authorities, if the purchase he is considering is important enough.

More than one otherwise prudent individual has been stung— and stung badly—by allowing himself to be talked into buying some mud-caked figurine which the seller purported to be a fourth-century B.C. Greek work or an example of second-century A.D. Roman art. Privately, even some established dealers will admit that they have been fooled. It must be noted, however, that reputable dealers will immediately and without question refund the full purchase price on any object that they sell and that later proves to be anything except what was represented.

The cost of having an independent authority expertize a work of art *before* he buys is the cheapest insurance any collector can obtain.

Notwithstanding all that I have said above, the beginning collector with only modest means at his disposal need not throw up his hands in despair at the thought of starting a collection of Greek and Roman antiquities. There are more of these around and available at reasonable prices than one might imagine. True, they are not the finest and the rarest and not of museum quality. However, they are still authentic, still beautiful and still very likely to increase in value as time goes on.

Besides, the astute collector starts small and gradually builds his collection. He can, by careful purchasing, buy items that he can later

sell or perhaps even trade to obtain something of better quality and greater value.

Then—although the chances are not great, they are better than is generally supposed—there is always the possibility of making a real "find" in some flea market or junk shop. It does happen that the housewife who picks up a bargain marble bust at a rummage sale later discovers that she is the astounded owner of a rare piece worth thousands of dollars. More than one individual in recent years has purchased, say, a bronze statuette for a few dollars in a European flea market and had it prove to be a valuable piece.

One must never forget that objects of art frequently have a strange habit of traveling far and to strange places—witness the *Cottenham Relief*.

It is entirely possible that if I could comb through every cluttered attic in old New England towns, I might find many worthwhile works of fine art that have been gathering dust, unrecognized for what they are, for many decades. Many such works were brought home by the men who sailed the merchant vessels and clippers of the eighteenth and nineteenth centuries. According to references in the old diaries and the memoirs of such men, Greek and Roman marbles and bronzes—which in those days could often be picked up for practically nothing in Mediterranean seaports—were among the souvenirs they brought back to the United States.

What happened to all those treasures? Are not at least some of them lying in attics or cellars?

And this is only a single example of a possible source. I could, allowing my imagination a little rein, think of several others—and so, I'm sure, could any of my readers.

This brings us to a crux. In order to be a successful collector of any type or school of fine art, an individual must learn as much as he can about it before he starts collecting. He must be able to recognize what he is looking for, and be able to recognize at least the more patent counterfeits.

The studying involved pays many extra dividends. In learning about ancient Greek and Roman art, one cannot help but also learn about the civilizations and the people who produced the art. This will

unquestionably serve to broaden the individual's intellectual horizons and, by increasing his knowledge and understanding of past civilizations, greatly aid him in knowing and understanding our own.

But then, all that is needed is a start—a beginning. Once an individual launches out as a collector, he will, in nine out of ten cases, become fascinated and enthralled. Even the most battered fragment of a statue, a headless terra-cotta figurine, or a cracked and dented bronze object will come alive, as fresh and as beautiful as the day when it was completed by its creator centuries ago.

And, when that happens, the collector can, at will, transport himself back in time and walk and talk with the great Greek philosophers, the emperors of ancient Rome, the people, great and small, of civilizations long dead, but which live again through the objects in his collection.

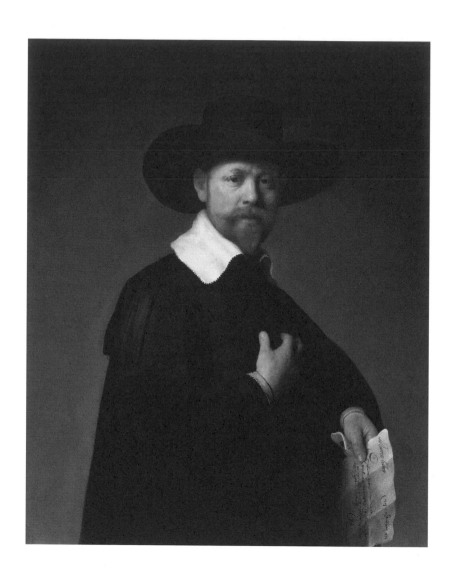

Rembrandt Harmensz van Rijn (Dutch, 1606–1669), Portrait of Marten Looten, *1632. Oil on panel. 92.7 × 76.2 cm (36½ × 30 in.). Los Angeles County Museum of Art. Gift of J. Paul Getty (53.50.3).*

A Rembrandt Masterpiece

I T IS FAR FROM UNUSUAL FOR A COLLECTOR to become involved in controversies over art. These may be as minor as a simple difference of opinion in regard to the exact year in which a particular canvas was painted. At the other end of the scale, he may become embroiled in—or stir up—a storm of dispute that falls little short of creating an international incident.

I know, for I once innocently found myself in the middle of just such a major imbroglio. The story of this incident goes back to 1928, when I attended the Rembrandt Exposition at the Boyman Museum in Rotterdam.

It would be utterly fatuous for me to add anything to the millions of words of praise which have been written and said about Rembrandt van Rijn and his work. The incomparable genius of this leading representative of the Dutch school of painting is too well known to require any comment from me.

Some forty of Rembrandt's paintings were assembled for display in the Boyman Museum—a fabulous *attroupement* of masterpieces

that literally overwhelmed the eye, mind and emotions, and which no person could reasonably absorb in a single visit. One of the pictures shown was *Marten Looten*, Rembrandt's second commissioned portrait, which he executed in 1632, when he was twenty-six.

The more recent chronological history of the portrait was well known. In the early nineteenth century, it was acquired by Cardinal Fesch, uncle of the French Emperor Napoleon Bonaparte. Cardinal Fesch was then serving as the French Ambassador to the Vatican. After the Cardinal's death in 1845, *Marten Looten* was sold and became part of the English Coningham Collection. In 1849 it was purchased for 800 pounds by Sir George Lindsay Holford and added to his collection. In 1928, the same year as the Boyman exhibition, Anton W. W. Mensing, a wealthy and intensely patriotic Dutchman, bought the panel from Holford's descendants for $204,000. Although he added it to his own collection, Mensing bought it primarily so that *Marten Looten* would be repatriated to its native land.

Marten Looten was a painting that caught and held me. I was drawn back to it time and time again. To employ a much-abused, but in this instance entirely valid expression, Marten Looten appeared as though he would step from the "canvas"—actually a wood panel—and begin chatting with the spectators at any moment. The portrait made such an impression on me that long after I left Rotterdam I was haunted by it.

Ten years later, in 1938, I learned the great Mensing collection was being broken up. Among the items to be placed on sale was the *Portrait of Marten Looten*.

I was then in the United States and the press of business prevented me from going abroad to attend the sale personally. I immediately cabled the dealer through whom I normally made my art purchases in the Netherlands, telling him I was definitely interested in obtaining the *Marten Looten*. Aware that the aftermath of the Depression and the precariously unsettled conditions in Europe were keeping art prices at comparatively low levels, I knew the portrait could not possibly bring anywhere near what Mensing had paid for it in 1928. However, so great was my desire to own the painting, I authorized the dealer to bid up to $100,000 for it. This figure, taking into consideration the times and

conditions which prevailed, was quite high. Also, following a practice entirely common in the art world, I instructed my dealer to keep my identity a secret and to say he was acting on behalf of an anonymous American.

The sale was duly held, the dealer acted to the letter of my instructions and, to my delight, succeeded in obtaining the *Marten Looten* for only $65,000!

At this point, a considerable amount of emphatic protest arose in the Netherlands, and particularly in Amsterdam. Segments of the Dutch press and public deplored the country's "loss" of the magnificent Rembrandt to an "unnamed American." Articles in Dutch newspapers and periodicals regretfully observed that a great national treasure would now go abroad, to a foreign owner and a foreign land. The loss was most keenly felt in Amsterdam, for Marten Looten, the subject of the portrait, had been a prominent citizen of Amsterdam in the seventeenth century.

Since the portrait had been in a private (the Mensing) collection and had been sold at a public auction, there were no legal or other restrictions on its purchase or its export. I knew that I had acquired the panel fairly and squarely and thought it best to ignore the criticisms that were being voiced and remain anonymous. I felt this course would tend to minimize the possibility of growing, or additional, controversy. It was the right decision. Before long, the Dutch aimed their criticisms at their own government, contending that it should have provided the funds necessary to top any and all foreign bids for the *Marten Looten* so that it could have been purchased for the Rijksmuseum. Nevertheless, a degree of regret lingered in Dutch art circles over the fact that the portrait had been acquired by an "unnamed American" and would therefore leave Amsterdam and Holland. Many years and World War II were to intervene before I would be able to erase the last traces of all such feelings in Holland.

In the meantime, the panel was shipped to me in New York, arriving there in January 1939. The New York World's Fair was scheduled to open on April 20 of that year. I contacted Fair officials and offered to loan the *Marten Looten* and some other important pieces in my collection for exhibit in the Fine Arts Pavilion. The offer was accepted

and as a result I was able to share my joy in owning the masterpiece with millions of people.

Another decade passed. August 1949 found me once again in Rotterdam. The fascination that the *Marten Looten* held for me had never lessened. On the contrary, it had increased to the point where I avidly desired to learn all I could about the painting and the man portrayed. Also, I wanted to see if I could discover anything that might help solve the long-debated mystery of the letter that Marten Looten is shown holding in his left hand.

There had been countless theories about the letter and its significance and meaning. Before I bought the *Marten Looten*, a Dutch physician, a Dr. J. W. Kat, had announced that he'd deciphered the words scrawled on the letter by a "chemical-optical" process, the nature of which he steadfastly refused to divulge.

According to Dr. Kat, the letter depicted was from Rembrandt to Marten Looten himself and read as follows:

> Marten Looten
> XVII January 1632
>
> Lonely for me was Amsterdam; your company, friendship just gave me unforgettable peace created from an endless respect.
>
> (Signed) R. H. L.

The name "Marten Looten" and the date are perfectly legible in the painting. The "RHL"—Rembrandt's actual name was Rembrandt Harmensz Lugdunensis—is also legible. But the text, four lines in the painting, remains gibberish even under the strongest magnifying glass. Consequently, Dr. Kat's announcement had been greeted with howls of derision in the Netherlands and in world art circles. Innumerable other students of Rembrandt and his work had advanced other theories, none of which were widely accepted. It was my hope that, through patient research in Dutch archives, I might unearth some clue to solve the riddle.

Last, but far from least, my reason for visiting the Netherlands was to clear up whatever misunderstanding and resentment still remained

as a result of my acquisition of the *Marten Looten* in 1938.

The art dealer who had acted for me at the sale graciously agreed to be my companion and act as my intermediary during my stay, using his considerable acquaintance and reputation to help open doors that might otherwise have been closed to me. When necessary, he also acted as my interpreter and translator, although this was seldom. The Dutch, like the Swiss, are usually bilingual or multilingual, speaking German and often English and French in addition to their own tongue. Although my own Dutch was limited to little more than guidebook phrases, I speak both German and French, therefore communication was not much of a problem.

Because I felt it would serve to provide me with a solid foundation on which to base my other efforts, I chose to tackle the identification of Marten Looten himself first. This required many days of searching through musty files, of shuffling through yellowed and fragile documents in the Rijksmuseum, town halls and elsewhere. Throughout it all, I carefully hid the fact that I was the unnamed American who had purchased the portrait. I posed, instead, as an American art journalist doing research for an article on Rembrandt.

Eventually, a fairly comprehensive description of Marten Looten and his life emerged from the hours of research and the masses of notes.

The Looten family had its origins in Aardenburg. Adherents of the Reform Movement, the family was forced to flee Aardenburg due to religious persecution in the 1500s. The Lootens went to Houndschoote.

In 1582 Spanish troops invaded Houndschoote and burned the city. The family sought refuge in Brugge. Evidently, the Lootens managed to salvage some of their wealth, for they were soon active and prospering in business again. It was in Brugge that Marten was born.

Some years later, the Lootens returned to Aardenburg, where they were now welcome. Dirck Looten became a brewer and eventually the mayor of the town. This peaceful, prosperous period was only a lull. The religious issue again forced the family to move, first to Aachen, then to Leiden.

Rembrandt's father, a well-to-do Leiden miller, became acquainted with the Looten family. Marten Looten, who was twenty years older

than Rembrandt, moved to Amsterdam. In 1631 Rembrandt himself moved to that city. The most probable assumption is that the young artist—then twenty-five—contacted Marten Looten.

It is entirely likely that Marten Looten was impressed by the work of the budding genius and encouraged him. After all, Marten had become a successful grain merchant. However, being the youngest of seven children and only fractionally as successful as his older brother, Charles, who had amassed a considerable fortune in business, Marten suffered from what we would describe today as a marked inferiority complex.

Thus, it is not beyond the realm of possibility that he commissioned Rembrandt to paint his portrait to satisfy his own vanity. There is a substantiating element in the fact that, soon after the portrait was completed, Marten bought a large property consisting of a fine house and gardens for the then impressive sum of 4,600 guilders.

Old tax records showed that Marten Looten was well off. In 1631, he was taxed on the basis of a worth of 30,000 guilders. Thirteen years later, the tax authorities assessed his fortune at 71,339 guilders.

As for the disputed letter and Dr. Kat's deciphering of it, we turned up considerable evidence to indicate the good doctor and his optical-chemical system might have slipped a cog somewhere.

The tone of Dr. Kat's version of the letter is one of a man who felt sad and alone and who was humbly thanking a benefactor for having shown him kindness. But Rembrandt could hardly have been lonely in Amsterdam by January 1632. He had many friends and acquaintances in the city, among them some fairly wealthy and important persons. He was a rising young artist whose work was already attracting favorable attention (1632 was the same year in which he completed his world-famed *Anatomy Lesson of Dr. Tulp*). Nor, at that period in his career, was Rembrandt van Rijn's personality and temperament of a type to write a letter such as Dr. Kat purported it to be.

No. All indications pointed to the conclusion that the letter was nothing more than an accessory, a prop, with four lines of meaningless scrawlings, which the artist had his subject hold to give the portrait a more relaxed and realistic quality and to improve the composition of the picture. It was also a novel means whereby he could at once title,

date and sign the panel. (Remember, the "Marten Looten," the date "XVII January 1632" and the initials "RHL" *are* legible.)

Further research revealed that the majority of authoritative opinion agreed with the conclusion I had reached.

Now I had achieved two of my goals. The long hours of research and study behind me, I felt that if Marten Looten ever *did* "step out of the canvas and begin to talk," I would be able to greet him and converse with him as though he were an old acquaintance. I also felt satisfied that I had solved the mystery of the disputed letter by determining that it was not, and never had been, a mystery at all.

Thus, I was ready to take on my final self-imposed task, making my peace with Dutch art circles.

One of the leading authorities on Rembrandt in the Netherlands was Professor Van Dillen, a member of the faculty at the University of the Hague. Coincidentally, he had also been one of the more outspoken critics of the sale of the *Marten Looten* to a "foreigner," and he deeply deplored the Netherlands' loss of the portrait.

I reasoned that if I could mollify Professor Van Dillen, prove to him that I was not an uncultured barbarian and that the display of the portrait in America had done, and would continue to do, immeasurable good by acquainting millions with the glories of Dutch art, the entire problem would be solved. I therefore asked my dealer friend to arrange an appointment for me with the professor.

"But don't tell him I'm the man who bought the *Marten Looten*," I said. "Just say that I'm preparing an article on Rembrandt."

"Why on earth do you want to do that?" my friend demanded.

"Because I want him to judge me without prejudice, as an individual, before he learns that I own the portrait," I explained.

Some days later, my dealer friend and I were received by Professor and Mrs. Van Dillen in their apartment on the uppermost floor of a traditionally styled old Amsterdam house—narrow, picturesque and located along a canal.

We had been invited for tea. I chatted amiably with the professor. Before long, a bond of warmth sprang up between us. I found him to be a learned, but by no means pedantic expert, with an excellent sense of humor and a great deal of personal charm.

Professor Van Dillen asked me many questions about the United States. Implicit, though never openly expressed, was his surprise that an American could be conversant with the fine arts and especially that he could possess any but the most superficial knowledge about Rembrandt van Rijn and his life and works.

Finally, I gently began to steer the conversation around to the *Marten Looten*. I asked the scholarly professor several questions about the portrait and mentioned that I had read some of the articles he had written about it—which I had done during the course of my recent research.

Soon, Professor Van Dillen shrewdly realized that I was showing much more interest in the *Marten Looten* than I would if I were merely preparing a general article on Rembrandt.

"Tell me," he murmured quietly, "why are you so intensely interested in even the most minor details regarding the *Marten Looten*?"

"Because, sir, I am the 'unnamed American' who purchased it in 1938," I replied.

The professor was startled, and for a few moments he said nothing.

"I can understand how you felt about it, sir," I continued. "However, the *Marten Looten* was not lost to the Netherlands—for it, like every Rembrandt, will forever be Dutch. The portrait is in America, that is true. However, it is acting as a cultural ambassador of your country and its heritage."

I went on to describe where and how the painting had been exhibited, how it had been viewed by millions and would be viewed by millions more, for I was soon to donate the *Marten Looten* along with some other of the finest pieces in my collection to the Los Angeles County Museum.

The professor's face gradually softened and finally broke into a huge and sincere smile. I had won not only my goal, but a friend. When at last we parted the last of Professor Van Dillen's resentment against the unnamed American had vanished forever. I knew that within a very short time, all hostile feelings throughout Dutch art circles would also be permanently erased.

When I left Amsterdam soon afterward, I felt deeply content. I'd accomplished much. Few collectors are fortunate enough to become as

intimately acquainted with their treasures as I had become with both *Marten Looten* and the master who had painted his portrait. I had satisfied myself regarding a controversy that had long raged over the letter which Marten Looten is shown holding in the painting. Above and beyond this, I had succeeded in ending a much greater controversy over the purchase and ownership of a great Dutch painting by an American. In that, I felt I had really accomplished something worthwhile, helping in at least some small degree to cement the bonds of cultural understanding and friendship between those who love and appreciate fine art in two countries, Holland and my own.

Excitement, romance, drama, a sense of accomplishment and even of triumph are all present in collecting. And I think this little story of the Rembrandt *Portrait of Marten Looten* serves well to prove the point.

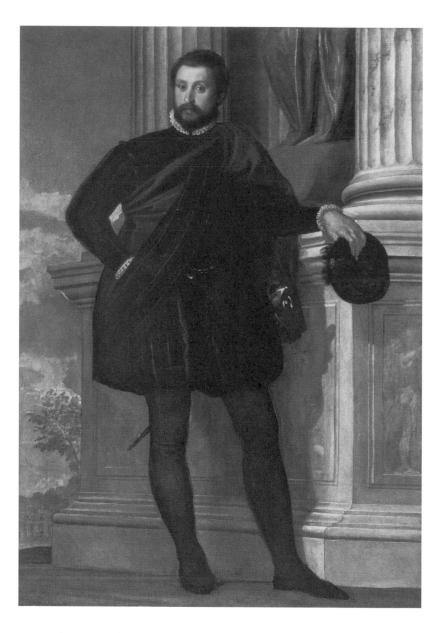

Veronese (Paolo Caliari) (Italian, 1528–1588), Portrait of a Man, 1576–78. Oil on canvas, 192.2 × 134 cm (75⅛ × 52¾ in.). Los Angeles, J. Paul Getty Museum, 71.PA.17.

Collecting Paintings

THE FOCAL POINT IN MY COLLECTION of paintings has been the Renaissance period. On the other hand, I have never pretended or aspired to assemble a completely homogeneous collection, to "super-specialize" by acquiring works which date from and solely represent that particular period.

I have already described some of the more outstanding of my digressions; it might be advisable for me to further explain and clarify my philosophy and approach.

It would not surprise me at all if the ultra-purists characterized my collection of paintings as one that lacks any clearly defined unity. Let the ultra-purists think what they may. Like the ancient eclectic philosophers who selected such doctrines as pleased them in every school, I seek to acquire such paintings as please me in the sense that I feel they possess true and permanent artistic merit and value.

I have often been asked why I've made no forays into collecting the ultra-moderns, or have not supported contemporary art. Those who ask me are always somewhat taken back by my reply—which is

another question.

"Why don't the avid collectors of contemporary art buy Titians or Tintorettos?"

I collect paintings that please my taste, and I believe that the collection on display at the Getty Museum is better for the fact that the items in it were selected carefully from examples of the schools and periods I know, understand and appreciate most.

However, although my tastes lie essentially in certain directions, I am grateful to say they have not atrophied. I think my tastes have remained sufficiently pliant to recognize and adapt themselves within reasonable limits to the merits and potentials present in other periods and schools.

Permit me, for the moment, to return to my ten paintings by the Spanish Impressionist Joaquin Sorolla y Bastida. By any ultra-purist's yardstick, these would appear to clash glaringly with, say, my examples of works from the Italian Renaissance or the Flemish school.

Sorolla y Bastida and Titian and Tintoretto or Rembrandt and Rubens?

To the pedant and doctrinaire, the combinations would be abominable in a collection. They would not imply eclecticism but anarchism. However, as far as I—and a great many other people who have seen and commented upon them—am concerned, the Sorollas perfectly suit the "Lanaii" Room of the Getty Ranch House–Museum in Los Angeles, where they are hung.

The room itself is large, light and airy. Its design, decor and furnishings are cleanly and simply modern. The Sorollas are naturally suited adjuncts to their surroundings.

Notwithstanding what I have written above, I often wonder why more people do not have the artistic imagination to grasp and understand the aesthetic impact of strong contrasts. For example, Sutton Place, where I spend a not inconsiderable portion of my time, is a manor house located near Guildford in Surrey, some thirty miles outside London. Dating from the first half of the sixteenth century, and built by Sir Richard Weston, one of King Henry VIII's courtiers, it is a magnificent, and some authorities claim the finest example extant of Tudor architecture.

Sutton Place, Getty's residence in England, in 1964.

The great old house has a long and thrilling history. Queen Elizabeth I stayed there for a time when she was a young girl. Richard Weston's son was beheaded by order of King Henry VIII for having allegedly committed adultery with Anne Boleyn, Henry VIII's second wife. Anne Boleyn was also beheaded by the King's command, and it is a centuries-old legend that her ghost haunts Sutton Place—particularly the "Red Room" (so called because of its predominantly red decor) which had been her bedroom during her visits to the manor.

Through the generations, Sutton Place collected its legends and traditions and finally became the country seat of the late Duke of Sutherland, from whom the property was purchased in 1960.

The principal reception rooms of the ancient mansion are huge. Many are lofty-ceilinged and richly paneled in oak, mahogany or pine.

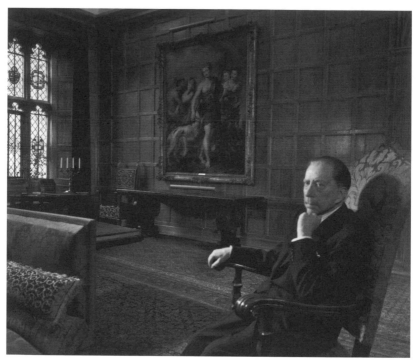

Getty at Sutton Place. On the wall in the background is the painting Diana and Her Nymphs on the Hunt, *now attributed to the workshop of Peter Paul Rubens.*

After Sutton Place was purchased, both the interior and exterior of the 72-room manor house were completely refurbished and restored.

The "Great Hall," which is 57 feet long and 25 feet wide with 31-foot-high ceilings, is a perfect room in which to display Rubens' large (92½ by 72 inches) canvas of *Diana and Her Nymphs Departing for the Hunt,* which I obtained in 1961, and the 60½- by 94½-inch Snyders-Boeckhorst *The Pantry,* a canvas I acquired in 1960.

The "Long Gallery"—165 feet long and 22 feet wide and oak-paneled from floor to ceiling—is perfectly suited for hanging Brussels and Flemish tapestry panels, as is the 65-foot-long dining room. The library, 135 feet long and 22 feet wide with its velvet-covered walls, high ceiling and large expanse of window area, lends itself ideally as

a "gallery" for large eighteenth-century portraits such as Pompeo Batoni's *Portrait of John Chetwynd, Earl of Shrewsbury and Talbot,* measuring 71¾ by 108 inches, and Gainsborough's 86- by 61-inch *Portrait of Anne, Countess of Chesterfield.*

What I'm trying to emphasize is that the periods, styles and sizes of the works of art I've mentioned ideally suit the style of the house and the rooms in which they are displayed. They "fit in" perfectly.

However—and I return now to my argument about the aesthetic impact of strong contrast—Camille Pissaro's *La Briqueterie à Erangny* or the Gauguin landscape, though apparently completely out of character with the other paintings, provides refreshing contrast. Rather than being distracting, or detracting from each other, the works of the old masters and those of the Impressionists, if properly and tastefully placed, serve to mutually highlight each other.

Before I loaned the *Madonna of Loreto* to the National Gallery in London for temporary exhibition there, it hung on a wall of the principal bedroom at Sutton Place. On another wall of the same room also hung Pierre Auguste Renoir's *Deux filles dans un pré, Two Girls in a Field,* as well as two other Renoirs, both small but exquisite examples of his work: *The Farm* (9 by 7 inches), and *Landscape, Midi-Southern France* (12¼ by 7½ inches).

The paintings proved to be entirely compatible companions. Raphael and Renoir can not only live together in friendly comfort in the same room, but each of the masters—although separated by centuries of time and vast differences in subjects, approaches and techniques—emphasizes the genius of the other and the merit and beauty of his work.

I'll be the first to grant that there are limits beyond which the employment of contrast should not, and cannot be carried. With all due respect to their creators, exponents and aficionados, I can't quite see hanging examples of Pop or Op art in the library alongside a Gainsborough or in the long gallery opposite an early-sixteenth-century tapestry. The result would not be an aesthetically pleasing contrast, but a ludicrous clash to jar the viewer's aesthetic senses and sensibilities. The extremes would be too great; the effect would be disastrous.

This is in no way to imply that I condemn Pop or Op art. Although my own personal tastes do run in different directions, I would not argue that either school lacks artistic merit for those whose tastes and preferences have developed along those lines. It simply happens that mine have not, and as I've said repeatedly, I purchase objects of art that appeal to my personal taste and standards of artistic merit.

But, let us consider briefly the individual whose taste in home or office furnishings and decoration runs to the modern, even the severely modern. Try to imagine the effect—the impact—of one or two good classical or Renaissance pieces tastefully placed in a living room or office to at once offset and, at the same time, favorably emphasize the uncluttered simplicity of the remainder of the decor. Such additions not only increase the charm and effectiveness of the whole, but reflect imagination and an understanding of the advantageous use of contrast.

Conversely, a room furnished and decorated in a more traditional style can be aesthetically enhanced by the astute placement of a modern piece or two. Needless to say, taste and discernment are necessary to achieve the proper effect desired in either instance. These are individual qualities that can be, and most often are, acquired and refined. In my opinion, precious few people are born with them. I certainly am not among those few. My taste and discretion in art developed through the years, aided and nurtured by reading, visits to art galleries and museums and the advice and counsel of those much more knowledgeable and experienced than I.

I do not suppose that it was until 1938 that the sum of all these influences began to truly bear fruit. That was the year in which I acquired among other works, Pickenoy's *Portrait of a Woman;* Willem Kalf's *Still Life;* Rigaud's *Louis XIV,* which hung in the Tuileries Palace until the French Revolution; Gainsborough's *Portrait of James Christie;* the *Marten Looten;* and, of course, what later proved to be the original Raphael *Madonna of Loreto.*

I did very little buying during the war years. Almost all my time and efforts were channeled into personally directing the crash-program expansion and operation of the Spartan Aircraft Corporation, a subsidiary of Skelly Oil Company, a corporation in which I indirectly held

the controlling interest. The story of my management of Spartan Aircraft has been told elsewhere and does not belong in this narrative. Suffice it to say that I took personal control at the request of Secretary of the Navy Frank Knox, who considered the tremendous expansion of Spartan and its efficient operation vital to the nation's war effort.

The production of airplanes and of subassemblies for thousands of fighters, bombers and other aircraft was far more important than art collecting. After VJ Day, I was immersed in reconverting my various companies to peacetime production.

Hence, it was not until a few years after the war that I was able to resume active collecting to any considerable degree. By 1951, business pressure had lessened sufficiently for me to get back into the swing. That year, the majority of my acquisitions were paintings, canvasses and panels of the Dutch and Flemish schools. Among them were Jacob Duck's panel, *The Rest of the Soldiers; Interior of the Church of St. Lawrence at Rotterdam*, a canvas by Anthonie de Lorme; Cornelis De Man's canvas, *The Family Meal*; Jacob Vrel's *Street of a Dutch Town*, a panel; and Joos Van Craesbeek's panel, *The Cardsharpers*.

Two years later, I was concentrating on Italian painters. The accretions to my collection during 1953 and 1954 include a sizeable number of paintings, some quite exceptional, by Italian masters. I list some below by year and, within each year by chronological order of the birthdates of the artists.

1953:
School of Paolo Uccello (1396–1475): *Battle Scene,* an odd-size
 (17½ by 65 inches) panel depicting the Siege of Troy.
Bartolomeo Veneto (c. 1480–1555): *Lady Playing a Lute,* panel.
Lorenzo Lotto (c. 1480–1556): *Portrait of a Jeweller,* canvas.
Bonifazio Veronese (1487–1553): *Portrait of a Woman,* canvas.
Gentileschi (Orazio Lomi) (1563–1639): *The Rest on the Flight to
 Egypt,* canvas.

1954:
Girolamo di Benvenuto (1470–1524): *Nativity,* panel.
Tintoretto (1518–1594): *Allegory of Vanity, Toilet of Venus,* and

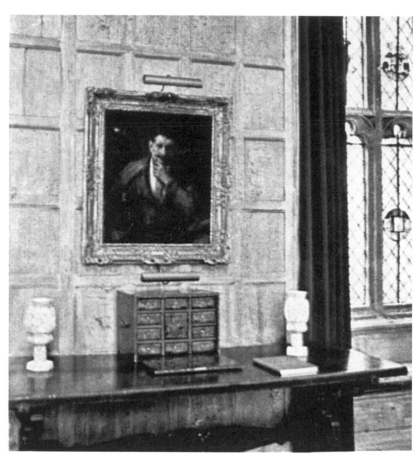

Rembrandt Harmensz van Rijn (Dutch, 1606–1669), Saint Bartholomew, 1661. Oil on canvas, 86.7 × 75.6 cm (34⅛ × 29¾ in.). The painting is shown hanging on the wall at Getty's residence, above a sixteenth-century German inlaid cabinet, which rests on a sixteenth-century Italian table.

 Portrait of Doge Priuli, canvasses.
 Paolo Veronese (1528–1588): *Portrait of a Young Man*, canvas.

Some of the more significant additions to my collection in the years which followed are listed below, together with the year in which I obtained each particular work.

The Death of Dido, Rubens (1955); *Penitent St. Magdalen*, Titian; *The Cliffs of Pourville in the Morning*, Monet; *The Village of Essoyes*, Renoir; *Three Dancers in Pink*, Degas (the last four paintings were all acquired in 1956).

The Square Louis XV in Paris, Moreau the Elder (1957); *Portrait of Anne, Countess of Chesterfield*, Gainsborough; *Seaside Landscape*, Degas; *Landscape Near Rouen*, Gauguin (the last three paintings were all acquired in 1959).

In 1960, my purchases included the Snyders-Boeckhorst *The Pantry* and Bonnard's *Woman in the Nude*. The following year, I achieved something of a coup by obtaining Peter Paul Rubens' breathtakingly beautiful and luminescent canvas, *Diana and Her Nymphs Departing for the Hunt*, a famed masterpiece for which I paid a very large sum of money. The next year saw another happy triumph. I succeeded in obtaining another Rembrandt, *Saint Bartholomew*, which throughout its long and meticulously documented history was variously and erroneously known as *The Assassin, Man with a Knife* and *Portrait of Rembrandt's Cook*. I purchased this painting at Sotheby's, paying 190,000 pounds sterling, plus 6,000 pounds commission, or a total at current exchange rates of nearly $550,000. I derived immense and special pleasure from acquiring this canvas for two reasons.

First, the *Saint Bartholomew* has helped ease my nostalgic longing for the *Marten Looten*, which I'd donated to the Los Angeles County Museum several years earlier. Second, I was highly gratified by the reaction in Dutch art circles to my purchase of the *Saint Bartholomew*. This time, according to reports I received, there were expressions of satisfaction and approval that the painting had gone to someone who had genuine love and appreciation for the work of Rembrandt van Rijn. My interview with Professor Van Dillen in Amsterdam had paid rich rewards.

A recent (May 1964) acquisition has been the *Self-Portrait* by Paolo Veronese (Paolo Caliari), which is on temporary loan to the National Gallery in London, along with the *Madonna of Loreto*. The *Self-Portrait* is in excellent company, for the National Gallery has hung it in a room that holds some of the choicest works of Veronese, Titian and Tintoretto.

According to data I have obtained, the Paolo Veronese had led a very interesting life, especially since the beginning of the nineteenth century, when it was well over 200 years old. In April 1802, according to the authoritative Italian book *Paolo Veronese, sua vita e sue opera* ("Paolo Veronese, His Life and His Works"), the following occurred (quoted in translation):

"In the month of April [1802] in Verona, the *Portrait of Paolo*, painted by himself, and belonging to the Countess Salvi-Pindmonte-Moscardi [*sic*], was sold to the Englishman, Lord Prijor [*sic*] for the price of 500 gold napoleons."

The next mention of it is found shortly before the outbreak of World War II, when the 76- by 53-inch canvas was purchased from an English country home by a Dutch dealer who took it to Holland. During the war, it was "acquired" by Hitler's right-hand man and chief of the Nazi Luftwaffe, Hermann Goering, and it became part of Goering's collection.

After the war, it was brought to England, where it was sold at Sotheby's. For some unaccountable reason, it brought a paltry price, namely £90. It was purchased by a dealer who, according to what I've heard, sold it before long for around $1,250, still a very meager price.

The painting soon came into the possession of a famous international art dealer. After his death, I acquired the Paolo Veronese *Self-Portrait* from his heirs in a private sale. I paid a price that was many thousands of times greater than the sum it brought at Sotheby's, but even so, art authorities tell me I got a great bargain. The painting, they say, is worth much more than what I paid for it, and it is acknowledged to be one of the finest works of Paolo Veronese and executed entirely by his own hand.

Space limitations have made it utterly impossible for me to mention or to include descriptions and reproductions of every painting I have acquired over the years. I have touched on only a few of the more important, unusual or especially interesting items. As for the illustrations and additional descriptions that appear in this volume, I feel that the editors have chosen carefully and well, selecting examples that provide a truly representative sampling and reflect the scope, range and "feel" of the collection.

Once again, I'd like to pass on some of the pointers I've learned. Much of what I said earlier about antiquities holds with equal validity for paintings.

As a rule, paintings should only be purchased through reputable dealers or, obtained through private sources, only after consultation with a qualified expert. There is, of course, an exception to this rule when dealing with living artists. Individuals who collect the works of contemporary artists can often buy directly from them at their studios.

Much caution is needed in buying paintings, whether those of old masters or living moderns. There are many, all too many, wrongly attributed or totally spurious paintings about, as well as large numbers that have been stolen from their rightful owners. Such is the traffic in bogus or stolen paintings that Interpol, the international police organization, was reported in 1963 to be establishing a special branch for the express purpose of waging war against art thieves and forgers. Art thefts are frequently reported in the press. Thieves know that a ready and lucrative market exists for their readily transportable loot. Highly organized gangs specialize in this form of larceny—for example, the gang that, a few years ago, broke into a French Riviera restaurant famed for its spectacular collection of modern paintings and stole more then twenty canvasses worth a fortune. These included works by Braque, Bonnard, Picasso, Rouault, Modigliani, Miró, Buffet and Dufy.

Counterfeits? They are legion.

As recently as June 1965, Italian police smashed an art counterfeiting ring operating in Florence, which, they said, had been operating for several years without being detected. The culprits had been producing (and selling) spurious paintings in wholesale lots—supposedly the work of such modern artists as De Chirico, Guttuso, De Pisis and many others. Indicative of the scale of the operation, the authorities seized no less than 150 bogus De Chiricos which the forgers had in their headquarters, ready for shipment.

So good was the counterfeiters' work, Italian authorities declared, that dealers and private collectors in Paris, Berlin, Stockholm, London and the United States had been completely duped. The police said that the forgers concentrated on counterfeiting modern artists whose

high status was accepted, but whose works were not so thoroughly cataloged as those of the old masters. It was estimated that some thousands of fraudulent works had been produced and sold by this one ring alone in the last four or five years.

Old masters are forged, too, and offered to and purchased by the gullible who fail to take the simple precaution of having the painting examined by one or more experts. I say "one or more" not because I am suggesting an expert may not render an honest verdict, but because some forgeries are so good that it may require several highly qualified authorities on the particular period or painter to detect the revealing flaws.

It might well seem to the reader that, and no play on words intended, I am painting a very dark and discouraging picture for the tyro collector or the individual who would like to start a collection.

But there are good buys available, regardless of what period or school interests the collector, in every European country.

By no means does the individual wishing to start a collection need to go to Europe to do his or her shopping. There are many highly reputable and totally reliable art dealers in the United States. Naturally, their prices are likely to be somewhat higher than those prevailing for similar items in Europe. There are transportation, insurance and other costs which must be taken into consideration.

Nevertheless, the shrewd collector and careful shopper can still find paintings of merit at prices to fit his means in the United States. And, it must certainly be borne in mind that there have been, and are, a great many fine American artists whose works are as good and as highly regarded, level for level, as those produced by artists anywhere in the world.

The individual who wishes to start a collection should never overlook the potential of young "beginning" artists. If the collector has a basic understanding and feeling for paintings and has developed his tastes to any appreciable degree, the possibility of finding an artist who will eventually reach top rank is always present. The Braque which once sold for $15 and in 1959 brought $155,000, and innumerable similar cases that I or any other experienced collector could cite, are positive proof of this.

Here, I would like to interject a few reminders that might seem minor to some, to others self-evident and thus redundant, but that concern matters all too often overlooked. The first regards the framing of paintings. It is foolish to purchase a painting and then to provide it with a frame of inferior quality or one which does not suit the painting. Any painting which an individual feels is worth buying and having deserves to be framed properly. Artists and art dealers can and generally will give constructive suggestions, taking into consideration not only the character and characteristics of the painting but also those of the room in which it is to be hung. When necessary, they will usually be able to recommend competent, reliable picture framers.

Next, I would like to mention the display of paintings. Obviously, no hard and fast rules exist. Much—in fact, almost all—depends on the painting, the nature, size and decor of the room in which it is to be hung and, last but not least, the personal taste of the owner. However, a painting should be displayed to advantage, so that it can "show itself" at its best. There should be artistry in the hanging of pictures on a wall just as in the paintings themselves. And, of course, a painting should have proper lighting—lighting that enhances its beauty and, whenever possible, serves to further emphasize whatever effect the artist has tried to achieve.

Last, a word or two about the care and preservation of paintings. They should not be exposed to extremes of temperature or humidity or to direct sunlight. When they require cleaning or repair, these operations must be performed by qualified professionals. A painting cannot be cleaned properly or safely by even the most meticulous housewife. (I know of one painful and ultra-extreme incident in which a well-meaning housewife took a hanging, an oil painting on so-called "monk's cloth" worth $750, and ran it through her washer-spin-dryer because it was dusty and grimy!)

By the same token, the repair of a painting or even of a good picture frame is hardly a chore to be undertaken by even the handiest "Mr. Fixit" home repairman. Such tasks are for specialists, and the amateur will at best only worsen the existing damage or defect, and at worst will cause irreparable harm and destroy not only the value but also the beauty of the painting.

These points covered, I would like to offer one final counsel. Whatever school or type of painting the collector chooses to collect, let the choice be his own, in accord with his own taste and preference. One of the greatest joys of collecting lies in the gratification an individual derives from obtaining an object that he wants and that satisfies his *own* tastes.

"Following the crowd," and collecting certain types of objects or certain schools of painting just because it is the "fashionable" thing to do or the fad of the moment, provides no real and lasting satisfaction, offers no excitement and gives no joy.

Someone once criticized my collection to Sir Alec Martin of Christie's, arguing that I collected in unrelated categories, that my collection lacked the singleness of purpose and the concentration that he, the critic, felt should characterize a collection.

The critic concluded his tirade by disdainfully sneering: "Paul Getty buys only what he likes!"

Since Sir Alec Martin's reply and comment have been widely published in a book written by Ralph Hewins, I feel that I can quote it here without compunction and without feeling that I am being unduly immodest in doing so.

"I don't hold it against him at all that his collections are an expression of the man," Sir Alec declared. "I'm rather fed up with these impersonal, 'complete' collections which are chosen by somebody for somebody else. The formation of his wonderful collection has been a public service."

No collector could hope for greater vindication of his collecting philosophy, or for higher praise of his collection.

Furniture and Objets d'Art

ON VIEWING THE *ARDABIL* carpet, James A. Whistler, the great American painter and etcher, confessed that he was awe-struck and declared it to be "worth all the pictures ever painted".

The *Ardabil*, measuring 23 feet 11 inches by 13 feet 5 inches, was made in Persia during the first half of the sixteenth century. It must have taken many years to make and was completed in 1539–40. It is universally conceded to be the world's finest Persian carpet. The *Ardabil* and a less superb but still magnificent carpet of similar size and two exquisite, smaller prayer rugs were loomed for the most holy of all Persian religious shrines, the Mosque of Safi-ud-din.

Such was the beauty of the *Ardabil* that for more than 200 years the Moslem Persians stoutly maintained it was "too good for Christian eyes to gaze upon."

The *Ardabil* and its three lesser companions disappeared from the mosque early in the nineteenth century. One story holds they were looted by invading Russian troops; another version has them being sold at great price by the shrine's custodians.

In 1890 the four rugs came into the possession of an English art dealer named Robinson. The dealer, aware of the value of his treasures, proceeded cannily. He offered the lesser of the two large carpets to British authorities at a very high price, handily neglecting to mention that he also owned its superior companion piece. A campaign was conducted throughout the British Isles to raise, by popular subscription, the money Robinson demanded. The necessary sum was collected, the carpet duly purchased and presented to the Victoria and Albert Museum, where it is still displayed.

Eager for American dollars, Robinson now sold the remaining three pieces, the fabled *Ardabil* and the two prayer rugs, to tycoon Clarence Mackay. The *Ardabil* passed through three great collections in succession, Mackay, Yerkes and De la Marr.

When the De la Marr collection was put up for sale, Lord Duveen was aboard a transatlantic liner. He heard of the event in mid-ocean and dispatched a radiogram to his New York associates to buy the *Ardabil* at any price up to $250,000. Duveen had no intention of purchasing the carpet for resale; he wanted it for his personal collection.

Prices realized at the De la Marr auction proved extremely disappointing to all but the buyers. To his astonishment, Lord Duveen obtained the *Ardabil* for what was literally a bargain-basement figure —$57,000.

I first saw the *Ardabil* at an exhibition of Persian art in Paris. I fully shared the feeling of breathless awe it had inspired in James Whistler and countless others. The carpet, with its magnificent pattern, colors and sheen, was one of the most beautiful things I had ever seen in my life.

I immediately contacted Lord Duveen with a view to purchasing it. He flatly informed me the *Ardabil* was not for sale at any price. Knowing him personally, I realized he meant what he said and with great reluctance abandoned all hope of ever owning the treasure.

Then came the great war scare of 1938. Art prices in Europe plummeted as dealers and collectors panicked. Cash, particularly American cash, became a much sought-after commodity, for it seemed to offer the greatest security in the conflict everyone expected would begin momentarily.

Lord Duveen—it must be remembered he was then 69 and had only a year of life remaining—was not entirely immune to the contagion of fear and uncertainty. He sent me word that he had changed his mind about the *Ardabil*. While it was true that the bottom appeared to be falling out of just about everything, Lord Duveen still virtually made me a gift of the carpet, selling it to me for slightly less than $70,000. I also obtained one of the two small prayer rugs that had been in the Mosque of Safi-ud-din.

Not very long thereafter, the Princess Fawzia, eldest sister of Farouk, then King of Egypt, was to marry the Shah of Persia (Iran). I was approached by intermediaries acting for King Farouk who informed me that he wished to buy the carpet and give it to his sister and the Shah as a wedding present. The gift was intended as an adroit diplomatic gesture, for it would have effected the repatriation of the epitome of ancient Persian rug-weaving art to its native land. The price suggested to me was in excess of $250,000.

I turned down the offer as politely as possible. For a time, I used the *Ardabil* as a carpet in the penthouse apartment I was then occupying in New York City. The apartment had a room large enough for it, and the superb, glowing *Ardabil* caused more than a few of my visitors to gasp with almost reverential admiration when they saw it for the first time.

Later, the carpet was loaned for display to the Metropolitan Museum of Art in New York. After that, it was transferred to my home in Southern California.

But, much as I reveled in the ownership of the *Ardabil*, I began to feel twinges of conscience about it. The Persians had averred it was "too good for Christian eyes to gaze upon." I, on the contrary, increasingly felt that the *Ardabil* was too good to be gazed upon only by the comparatively few people—Christian or otherwise—who visited my home. I therefore made a decision that, I must confess, was not entirely without pain, and donated the *Ardabil* carpet to the Los Angeles County Museum. I also donated another rare and exquisite example of sixteenth-century Persian rugs to the museum. This was the famous *Coronation Carpet*, so called because it had been borrowed from its owners for use in Westminster Abbey during the coronation

of King Edward VII in 1902. I had purchased this Safavid Dynasty carpet at Christie's in 1930 for $31,500, a small fraction of its actual value.

In one of its quarterly bulletins, the Los Angeles County Museum described the *Ardabil* as "the million-dollar carpet." Independent experts have concurred in this estimate of its worth and feel that the value of the *Coronation Carpet* is almost as great.

Despite these gifts to the Los Angeles County Museum, I still retained a respectable collection of high-quality Persian rugs and carpets. Although none approached the *Ardabil* or the *Coronation Carpet* in value, many fine examples of Isfahans and Feraghans and Kermanshahs remained.

I have often been asked why I have devoted so much of my energy as a collector to acquiring carpets, tapestries and furniture. There are two reasons. First, I do not subscribe to the theory that only paintings, sculpture, ceramics and architecture qualify as major fine arts. To my way of thinking, a rug or carpet or a piece of furniture can be as beautiful, possess as much artistic merit, and reflect as much creative genius as a painting or a statue. Second, I firmly believe that beautiful paintings or sculptures should be displayed in surroundings of equal quality. Few men would dream of wearing a fifty-cent necktie with a $300 suit, yet all too many collectors are apparently content to have their first-rate paintings hang in a room filled with tenth-rate furniture that stands on a floor covered with a cheap machine-loomed carpet.

There is, I fear, a grave and widespread lack of understanding and appreciation for fine furniture and carpets even among people who consider themselves highly cultured and deeply interested in fine art. I have seen numerous demonstrations of this at the renowned Wallace collection in London. Crowds of visitors there will view the paintings on the walls of the rooms with rapt attention and sincere admiration, totally ignoring the glorious examples of furniture that are also on display.

Perhaps it is because the average person is conditioned to consider all furniture to be primarily utilitarian and only coincidentally decorative, and even then only decorative, not a form of art.

Whatever the basic cause or reason, it remains that rugs, carpets and furniture are seldom thought of as important art forms by most

people. At best, they will think and talk in terms of antiques without consciously associating them with fine art. Hence, one constantly encounters such phrases as "collection of art and antiques," the obvious implication being that one has no relation to the other.

I must confess that I was one of that majority for quite a long time, viewing furniture and floor coverings casually and mainly as utilitarian objects. As long as they were comfortable, not unpleasing to the eye and harmoniously arranged, I paid them no special heed.

It wasn't until I found myself in need of a home base in New York City and leased an apartment there from Mrs. Frederick Guest that I suddenly became aware that furniture could have great artistic and aesthetic merit. A lady of infinite charm, great culture and impeccable taste, Mrs. Guest had furnished her apartment with an outstanding collection of eighteenth-century French and English furniture. One would have had to be a totally insensitive clod not to respond to the environment and to be impressed and influenced by it.

It wasn't that a spark was struck. It was rather that a blazing torch was applied, and my collector's urge flared high. I began to read and inquire, only to find that I was delving into a field that was highly complex and specialized, to say nothing of being strewn with perils and pitfalls for the tyro. Nonetheless, I refused to be dismayed or deterred. On the contrary, I went to the extreme of retaining several highly regarded art historians and authorities on fine furniture and carpets to give me cram courses on the techniques and tests for judging the authenticity and weighing the merits of such objects.

The more I learned, the more I was drawn to eighteenth-century French furniture.

The eighteenth century was the Golden Age of furniture, and France ruled supreme in its production. The Regency Period (1715–23) introduced the Rococo style, and interior decorations were made to match. For the first time since antiquity, the interiors of houses were designed for comfort and charm rather than for pomp and show.

The furniture of the Regency reflected a new style; straight lines were replaced by graceful curves, everything was less massive, less monumental. For example, the commode is an invention of the early eighteenth century and it soon became popular, for it contributed to

the comfort and elegance of the new interiors.

Under Louis XV, who reigned from 1723–74, furniture became still more graceful, reflecting the feminine influence of Pompadour and Du Barry. Small secretaries with fall fronts, small boudoir tables and gueridons became popular. Rolltop desks are an innovation of this period, the classic example being the *Bureau du Roi* by Oeben and Riesener in the Louvre. It has been said that this is the most valuable piece of French furniture to come down to us and that it would probably bring as much as $500,000 at auction today.

Louis XVI (r. 1774–92) furniture is still feminine and delicate, but the taste of the times was classical and the curves of the Rococo period were replaced by straight lines.

Attempts to imitate great eighteenth-century furniture were made in the nineteenth and early twentieth century. The best imitations were produced by Dasson and Beurdeley in Paris between 1860 and 1890. Their imitations are difficult to distinguish from the genuine because they were made with the same materials and tools as the originals. There was no profit, however, in producing these almost perfect imitations. The standard of workmanship and material was so high that the imitations sometimes cost more than the originals would have brought at auction. The Wallace collection has a replica by Dasson of the famous *Bureau du Roi* by Oeben and Riesener. The replica was two years in the making and the out-of-pocket cost to Dasson was about 50,000 francs, or $10,000. This, at the time—the greater value of money and other factors considered—was not much less than the original would have brought if then placed on sale.

Beurdeley's commodes are top quality and are rarely recognized or identified as copies. On the other hand, common imitations of eighteenth-century furniture can generally be recognized at first glance by an expert. The wood is not old wood, the mounts are electroplated instead of mercury gilded, the chasing is shallow and mechanical and the whole thing simply doesn't "look right."

Soon after I'd decided to begin collecting French eighteenth-century furniture, I met Mitchell Samuels, the noted art expert and dealer associated with French & Company in New York City. Samuels

had the complete confidence and respect of innumerable serious collectors and he quickly won mine. He graciously consented to give me his counsel and cooperation. I asked him to keep his highly trained and discerning eye open for any particularly good pieces which might become available.

Eventually, I had the good luck to assemble a collection of which I am proud. My acquisitions have come from many sources, some entirely unexpected. I should also mention that some of the purchases I made at sales were made under conditions that were distressing to the owners of the items, conditions over which neither they nor I had any control whatsoever. It has been my earnest hope in all such instances that I was of some benefit to those who had to sell because I was the highest bidder, paying the highest price anyone present at the sale was willing to pay. Otherwise, of course, I could not have been successful in purchasing the items. Luckily, instances such as these were few and far between. The overwhelming majority of my acquisitions were obtained under entirely normal circumstances.

Mitchell Samuels, with whom I became close personal friends, proved to be a uniquely talented and able buying agent. Through his efforts, the foundation of my collection was built. He assembled a nucleus of choice pieces around which I could, frequently with his advice and counsel, build further.

June 1938 proved an important turning point for my collection. Mortimer Schiff, financier son of the great banker Jacob Schiff, had formed a truly impressive collection of French eighteenth-century furniture, carpets and porcelains in his lifetime. On June 22, 1938, his collection was offered for sale in London. Prior to the sale, I went to the salesrooms with a friend, Leon Lacroix, who possessed considerable knowledge about eighteenth-century furniture. Together, we examined the items that were to be auctioned, and I made careful note of those I wished to buy.

Normally, in those days, I seldom attended such auctions or did my own bidding, preferring to have an agent act for me without disclosing my identity. This minimized the chance that I would be tagged as an active collector and consequently swamped with offers, catalogs,

letters and cables, and personal visits from dealers from all over the world, which is the fate of all collectors who allow themselves to become known.

In this instance, I departed from my customary rule. I attended the sale and found the galleries jammed. It seemed that every English and French art dealer—plus a huge throng of other people—had also decided to attend the auction. My heart sank. With such an assemblage of potential buying power present, I believed I stood little chance of obtaining what I wanted, at least not at the prices I'd be willing to pay.

To my astonishment, most of the people proved to be viewers, not buyers. Bidding was sluggish, at times becalmed. Items placed on sale went for prices far below what might have been conservatively anticipated. Again, the grim tension and uncertainty that prevailed that year in Great Britain and Europe were having their effect.

I regained my confidence and entered into the bidding. Before the sale ended, I acquired several superb pieces that, when added to those I'd already obtained through Mitchell Samuels, formed a first-rate collection. And, what is more, I won out over competing buyers with bids which, if someone had suggested even a few days earlier would be successful, I would have considered impossible.

Among my purchases at the Schiff sale were the following:

A magnificent Savonnerie carpet, one of only two ever positively
 identified as having belonged to Louis XIV before 1667
 (the other is in the Louvre).
The famed Molitor rolltop desk.
A Carlin Sèvres plaque side table.
A Tilliard damask sofa and chairs.
Two Chinese porcelain vases with French ormolu mounts.
Two Carlin Sèvres plaques gueridons.

That same year, also in London, I acquired from a dealer a writing table created by the mysterious all-time master of French eighteenth-century furniture who signed his works only with the initials: "BvRB." In recent years, he has been tentatively identified as Bernard van

Rolltop Desk, ca. 1785–88. Made by Bernard Molitor (French, 1730–after 1811). Fir and oak veneered with mahogany and ebony, gilt-bronze mounts; "griotte" de Flandre marble top. H: 137 × w: 181 × D: 87 cm (H: 4 ft. 6 in. × w: 5 ft. 11¼ in. × D: 2 ft. 10¼ in.). Shown here at the original Getty Museum in Malibu. Now at the J. Paul Getty Museum, Los Angeles, 67.DA.9.

Riesenberg, a craftsman of Dutch origin who, for some unknown reason, preferred to remain anonymous save for his initials and who produced some of the greatest pieces of furniture ever made in France.

Incidentally, and throwing my narrative completely out of chronological kilter, I much later acquired another BvRB piece. This, the "Husband and Wife Desk," has been described by Pierre Verlet, Chief Keeper of the Department of Furniture and Objects of Art of the Louvre, as "the most outstanding" example of this type of desk. While

I'm at it, I might as well relate how I acquired this rare piece and thus confess to one of my colossal blunders as a collector.

In 1950, I happened to have lunch at White's in London with an old friend, the Duke of Argyll. Over coffee, he remarked that he had inherited "some eighteenth-century French furniture" and among the items was a desk he was willing to sell.

"If you're interested, you can see it," he told me, adding that it was in his ancestral castle located in northern Scotland.

He spoke in an extremely modest and offhand manner. As I did not relish the idea of making the trip, for it was the dead of winter, I decided to first consult a friend of mine who supposedly knew every piece of good eighteenth-century French furniture in the British Isles. I asked him if he thought the Duke had any pieces of museum quality among the items he had inherited. No, I was assured, there was nothing of particular importance. Hence, I did not make the trip to the Duke's castle in chilly northern Scotland. Instead, I left England soon thereafter for sunnier climes.

The reader can well imagine my chagrined reaction when, a few months later, my friend, the art expert, visited the duke in his ancestral home and identified the desk His Grace had so casually mentioned to me over lunch as being the magnificent BvRB "Husband and Wife Desk."

Clearly, I had missed a tremendous opportunity, for the duke — alerted to the value of the extremely rare and superb piece — had gotten in touch with several leading art dealers.

A year later, I learned that a prominent New York dealer had purchased the desk. I approached him and was able to buy the piece for my collection. It is worth every penny of the price I paid for it—but the price was much, much steeper than it would have been had I been shrewder and acted swiftly and personally after my luncheon with the modest Duke of Argyll. — That anecdote sheepishly recounted, I shall return to the mainstream of my account.

After the infamous Nuremberg Laws were passed in Nazi Germany, the possessions of the Vienna branch of the Rothschild family were sequestered by the Hitlerian regime. Alfons, Louis, and, somewhat later, Eugene Rothschild succeeded in getting away from the

Nazis and managed to salvage a few pieces from their once immense and priceless collection of French eighteenth-century furniture. These were offered for sale at the greatly deflated prices characteristic of the period. For example, among them were two secretaires that, before the Depression, had been valued at $200,000 a piece, for they were exceptionally fine examples of the work of Carlin and Weisweiler. I purchased both from the widow of Alfons Rothschild (he'd died only a short time before the sale) for only $72,000, a price above which no other collector was then prepared to go.

Altogether and over the years, I have acquired many choice pieces from the collections of members of various branches—Vienna, Paris, London—of the Rothschild family. A few examples of these will suffice to indicate their type and quality:

Three Boucher Beauvais tapestries depicting the *Story of Psyche*.
A jewel or medal cabinet with a turquoise blue-bordered
 Sèvres plaque decorating its door.
An upright Louis XVI secretaire; two Carlin gueridon tables
 and a Carlin music stand; two Louis XV corner cupboards\definitely
 identified as the work of another great French cabinet-maker, Jacques
 Dubois; a Jean-Henri Riesener writing table.

Among some of my other acquisitions from various sources through the years:

A Guerault table, the only other example comparable to which is in the Louvre; two Charles Cressent writing tables; a blue Sèvres vase with a bronze gilt base that had belonged to Marie Antoinette; and a commode by Gilles Joubert, the renowned *ébéniste* of Louis XV, made for "*Madame Louise de France*" and delivered by Joubert for use in her bedroom at Versailles.

Again, limited space prevents a complete listing here of all the items in the collection of French eighteenth-century furniture, almost all of which are now in the J. Paul Getty Museum. I would, however, like to say a few additional words about the tapestries in the collection.

Getty in the library at Sutton Place with (from left) Col. Leon Turrou, his bodyguard; Norris Bramlett, his chief accountant; and Robina Lund, his chief British legal counsel. Getty's Gobelin tapestries can be seen in the background.

Altogether, I acquired several tapestries. Among them were four out of five of the Boucher Beauvais panels adapted from the legend of Psyche; several of his panels depicting the *Loves of the Gods;* and an extremely rare Boucher, a large panel into which two subjects of the *Loves of the Gods* are woven.

I also obtained some other fine examples of Boucher's works, along with Gobelins, sixteenth- and seventeenth-century Brussels and Flemish panels and other examples of this now all-but-lost art form.

Part of my collection of tapestries has been donated to the Los

Angeles County Museum. Most of the remainder are now the property of the J. Paul Getty Museum.

The comments and suggestions I made and the warnings I sounded in foregoing chapters are all applicable to the collecting of furniture, carpets and tapestries.

Museum-quality examples are hard to come by—and, when placed on sale nowadays, are all too apt to command sky-high prices.

But, as with antiquities or paintings, the fantastic bargain or the fabulous find is always a possibility. This is, perhaps, more true with regard to period furniture and carpets than with paintings and sculpture. For surely, there are store rooms, cellars, spare rooms and garages across the length and breadth of the United States that, unknown to their owners, contain unrecognized period pieces of considerable value that are considered only as castoffs by their proprietors. The day when a table or chair purchased in some squalid, jumbled back-alley junk shop turns out to be Regency or Chippendale is far from past.

There are also pieces of practically every period that, although not of museum quality or the work of famed artists and craftsmen, are still lovely and well worth collecting. Here, too, one can find prices extending across a wide range, and even the individual with a slender purse can obtain examples that have artistic merit.

On the other hand, imitations, "reproductions" and plain forgeries are as common in furniture as they are in other fields of art, and possibly even more so. There are also many instances in which carpets and tapestries are misrepresented. For example, it takes an expert to tell the difference between Beauvais and Aubusson. The former is far more valuable than the latter, and I'd guess that more than a few unwary buyers have been snared by unscrupulous sellers, paying Beauvais prices for Aubussons.

It is not overly difficult for the unethical dealer to convince the untrained lay buyer that a carpet or tapestry is much older than its actual age, or that a piece that contains sizeable areas of modern, imitative repair work is entirely original.

But, then, the problem of misrepresentation extends into all fields and forms of art, and laymen and tyro collectors are by no means the only ones liable to be victimized.

I recall one incident which serves as a textbook illustration of this. Among his many other attainments, Mitchell Samuels had long been recognized as being one of the world's great authorities on period wood-paneling. Some years ago, I was with him on a visit to an American museum, the name of which I shall mercifully omit.

During our tour of the museum, a tour conducted personally by its director (who shall also remain anonymous), we were taken to view a paneled room that, it seemed, was one of the institution's prouder exhibits.

The director at first beamed as he waited to hear Mitchell's verdict on the paneling. Then, after Samuels had run his highly trained eye over the walls for a minute or so without bursting out with words of praise, the director began to get a bit nervous.

Finally, Mitchell turned to face the museum director.

"What do they say it is?" Mitchell inquired innocently.

Now, the museum head was becoming distinctly apprehensive.

"George I paneling," he replied trying to maintain a confident air.

Mitchell cleared his throat.

"Um," he nodded and then suddenly asked the director a rather surprising question: "How old are you?"

"Why—I'm fifty-four," came the startled reply.

"Well, believe me—you're older than this paneling!" Samuels declared.

The director's reaction can be better imagined than described.

All collectors are well advised to make all their purchases through reputable dealers and to call upon experts to verify the authenticity and value of all items they are interested in purchasing.

Not everyone can be fortunate enough to have as fine and knowledgeable an expert and friend as Mitchell Samuels as an adviser. But there are large numbers of men and women of unquestioned ability and integrity who can—and will—expertize items which are being offered for sale.

Incidentally, art historians at our colleges and universities form a body of experts that, for some strange reason, many collectors fail to draw upon. Perhaps it is because some people tend to be overawed by such titles as "professor" or "doctor" and are thus afraid to approach

these authorities. Possibly, there are other people to whom it has never occurred that a college or university art historian can use his knowledge for purposes other than teaching, or writing weighty tomes.

Even those who collect on a very modest scale and fail to tap this great reservoir of expert academic knowledge are making a big mistake. Very often, a serious and costly blunder can be avoided or, conversely, a triumphant collector's coup can be insured by the simple expedient of contacting a member of the art faculty at the nearest college or university.

The professor or assistant professor or instructor will be able to provide expert knowledge, or at the very least, refer the collector to a source from which it can be obtained. Doubtless, the faculty member will do the necessary expertizing on his own time, and it is entirely ethical, indeed customary, to pay him a reasonable fee for the service. The fee, quite naturally, will vary according to the amount of time and effort expended and the value of the object on which expert advice is needed.

No matter who the reputable, established expert consulted — professor, art historian or dealer — his advice and help will be of great advantage and value.

I repeat, using what I believe is the slogan of the nation's better business bureaus: "Before you invest, investigate."

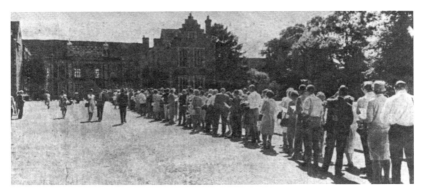

A crowd waits to view Getty's art collection at Sutton Place.

This admonition is as valid for those who invest in fine art as it is for those who invest in stocks, business enterprises or in *any* thing, project or scheme. And for the collector who is, after all, an investor in fine art, the best, most expeditious and most reliable way to investigate is by seeking the advice and counsel of qualified art experts.

If an individual decides to collect furniture, carpets or tapestries, let the decisions regarding the types of items, and the particular periods that he wishes to collect be his own. As with collecting any type of art or, for that matter, collecting anything, whether stamps, coins or streetcar transfers, the individual should follow his own preferences and satisfy his own tastes.

It is thus that one savors the zest, and thrills to the joys of collecting!

Suggestions for Further Reading

Getty, J. Paul. *As I See It: The Autobiography of J. Paul Getty.* 1976. Reprint, Los Angeles, 2003.

————. *Europe in the Eighteenth Century.* Santa Monica, 1949.

————. *How to Be a Successful Executive.* London, 1973.

————. *How to Be Rich.* London, 1966.

————. *My Life and Fortunes.* New York, 1963.

J. Paul Getty Museum. *Handbook of the Collections.* 7th ed. Los Angeles, 2007.

Le Vane, Ethel, and J. Paul Getty. *Collector's Choice: The Chronicle of an Artistic Odyssey through Europe.* London, 1955.

Illustration Credits